T0151079

YOUR BODY FIGURED

Nightboat Books
New York
2008

YOUR BODY FIGURED

DOUGLAS A. MARTIN

"So I'm a thief. . . . born to plagiarize, to imitate,
to act as the promoter of my masters. I steal, I take,
until the word 'take' can be altered: I take off . . . "
— CATHERINE CLEMENT,
The Weary Sons of Freud

Balthus

This is the problem with a great poet.

It is the story of how you became who you were, how you read these reflections to find yourself. How red you would become if too much was put together all at once, and your mother would then notice.

She is walking around the edges of the park.

She and Rilke are admiring the swans.

You are noticing the way the lake is pooling and pulling at your feet.

There you are, by those banks, gathering something like thistles in your hands.

Something glides out along the water, and then the sun ripples.

Something begins edging along inside you.

Mother, look at the swan, you once wanted to say.

He tries not to condescend to you.

He's this great poet. He believes in you, too, just as your mother did, even at this early age.

He's a great man.

You are watching your mother as she takes refuge in this myth.

———

Later, he will in fact dedicate a work to you, one or two poems.

He wrote them in a year you still knew him.

They remain uncollected, a longer work and a shorter one.

It's that myth that occurs most easily to him whenever he thinks of you, likes to think of you as Narcissus.

You'd watch him, watch him across the carpet or the stones up and down the walkway outside the castle where you'd come to live with him and your mother, all those summers, summers poring over those myths in your books.

He might have been thinking of you.

You might have been thinking of him, studying for him.

He'd try to slowly work you farther into this, closer towards that realization of what and who you could some day be, how.

You could grow up to be so many things.

He is proposing a trip for you.

He and your mother think you should go to Italy, to study paintings.

Why don't you go into your room and read. Spend another hour with your books.

Your date of birth appears and disappears, an upset occasion.

Rilke will change your perception of all this, the particular significance of having been born during a leap year, on just that one extra day only every so often.

It's a fact he could make something more poetic of.

They are changing your name again.

Why don't you go into your room and read, dear.

You'd watch him, watch him read to himself, silently, as your mother bustled about him. You'd find yourself occupied across from him on the carpet, holding the pages between your fingers.

He is the one who wants to teach you how to slip into myth, will father you in that.

You were reading to find yourself somewhere in some book.

Your face will beam a little differently, once you look up.

The more they notice you, the redder you'd become.

You'd get even redder if he saw how much you hated to see him go.

You are reading, like you don't even notice his exiting. Pretend too you don't feel like some little girl sometimes around him.

You were learning how one detail could be brought into a sharper set of focuses, or further obscurities in your hands. It would all be up to you now, whether perception was clouded or cleared, what you'd allow to be seen of you in any future.

He was writing on love, when he wrote about flower parts, of the bright groins where the genitals burned, to use his words.

You were learning.

With a hand raised farther up the inside of another's leg, a boy on the street would find that place, hidden, where he might differ.

Of stamen on stamen, he wrote.

Of turning into a swan.

———

This was existence, the shifting of light around bodies.

You'd change your life from this moment on so as to never be subjected again to anything like that war that's raging all over the world. That has nothing to do with you, you want to believe.

You and your mother and older brother are running from it.

Become someone else, you'd tell yourself, but you don't want to completely lose sight of yourself. He wouldn't want you to completely lose sight of yourself, and your gifts. Don't

reflect any longer, if you could help it, on your mother at home crying still late into some nights.

Your father is somewhere else.

You could take yourself out of life, and you could become someone else, if you tried, concentrated hard enough.

Study the way others lumber along.

Study the way they stand there in the grass, under the sun, the way the men turn around with their hands in their back pockets, then place their hands on the lower backs of women. You would not be touched like that.

You are a boy of fourteen. Rilke loves you like his own. He loves you all, all of you, you and your mother.

Which myths will fix you. There are boys chosen, embraced by kings, the sun for one, filled with strengths, chosen for their flaxen hair, their singular graces.

You are a darker one, ask your mother where you come from. You didn't like how your last name sounded. Up in your room, you are already beginning to try out other names.

Markings begin pegging you as this one thing, you.

Your brother goes off to Paris to study. Rilke and your mother suggest Italy for you. Off, away, no one would know you. No one would be the wiser.

You'd follow the advice of one great poet.

Here he came now, to pull you up in his arms, swan you, a feeling in each one of your eyes, deeper, disguised.

Sundays, the gaits of the couples, as they glide through parks, disturb the waters they trail their hands along. Disquieting, they circle, around reflections in the pond.

One moves towards another. One becomes another. One goes there to find them, to watch how they move closer, in steps, to other bodies, as eyes dart around, then feel they've found somewhere to stop. Existence was seeing. They are like people in paintings. Cheekbones become more set, polished, washed in shadows.

There's a point where the past begins giving way. He won't be joining them. How a bride bridges life. Families stand somewhere silently behind, as he hides away.

A distance opens up inside one, and begins living there, spreads between him and the world in him. Life embedded in flowers, refuge is taken in girls.

He's taken your mother away.

Here you were now in Italy, some other city, away under the trees.

You were off studying art.

The air would be cool all those days outside. You would walk along the flagstones, watch them wave away under you. It's what happens when you move your head from side to side as you walk. You continue on to the cooler recesses of a museum.

You are a boy whose legs are getting longer and longer day by day, every day now. There you are in the shadows, easing your way up under the marble staircase.

You are a boy who is going to be a painter, cooling yourself off now up against the wall.

It slips under your hands, a little wet still from the fountain out front.

———

This is what Rilke might have meant about how you could escape with your own thoughts, a place into which nobody could be quite sure how to follow you. You are reclining under an abundance of lime trees. In Italy, they create a bower over your head. Their shadows wing across your middle, putting you half here in the light, half still in shadows, between here and somewhere else.

Reflect on yourself growing wherever transplanted, being only as seed.

Reflect on the roots that make their way down into the richness of the loam beneath you. You pull up handfuls of tendrils. Throw roots out towards the place where the sky and sea meet, towards eternity.

You don't want to see yourself as this boy, some boy, so you keep moving along, sifting the ground beneath your feet, thoughts shifting.

The girls here are too young to be mothers. They run home to their own, at the ends of days, the ceasing, home to mothers who see themselves in the springs of their girls.

In the parks, fathers pull them along by hands. If they are still barely able to walk, they might be picked up, put up on shoulders.

You have your mother's nose, feel it there on the edge of the pond.

Everything could take another direction.

Your mother was still back there with him, away with him. One day he'll leave you two.

A great poet's work was out in the world, searching for words to ground, root the more elusive, and on occasion choosing ones for their special ability to slip, dropping them back behind him, like so many stones to possibly skip along.

———

It was cold that day in the mountains, as you edged closer towards the ebbing of an existence.

The crowds spilled around, and later you might have been left alone, finally, up there in his single room, among the collection of nibs, some broken, arranged, haphazardly.

You know flowers will ring around where his body was lowered, left to itself, under soil, or so you wish to go on believing.

Your mother always wanted to believe he'd still return some day.

He was there for her, for a while, until he slid down into his death, on a bed where he was able to gather enough courage to lurch up once, disturbing the light dashing against his shadow, lengthening further up.

Sweat salted his skin, while outside the last leaves fell, twilight pearls and then grays.

Your face slipped under the water in a sink off to the side.

They'll bury him in snow and rocks.

You would like to think you were able to stand there, watch every last drop of his life slip away.

They'll bury him in a hole, awaiting him.

———

When Rilke dies, things come to light.

You up in your room mix your palette, getting deeper and deeper now down into your work.

You notice the way a green could be turned to menace, notice the way the mountains now melt a bit in the foreground, yellow.

Notice the way you think of him as you paint, accumulating these traces, these names for this, this here.

You are feeling the mix of these contradictory, chosen things.

You are lifting your arms, accepting movement.

You feel how the ground shifts once again, high up in your own room, things before you spinning slightly away, growing light, slight here, as you concentrate on the edges of them.

You are painting the drape of the sheets, only, painting with all the concentration of your emotion exerted. You are still young. You still have all the time in the world.

When you think words like father, what you feel inside gathers faster, and often to better effect.

Rilke would level no accusations at your subject matter, would only encourage. He was a great poet, named after a girl. His mother set him down somehow on this path.

These are some of the details that make up a life, come to embody a figure. You open your mind to the canvas. Think father. Think how Rilke wanted you to open up a space for yourself.

You must be.

You must be feeling more than filial, at this moment.

Your mother is not up there, in the mountains.

You mourn him. Think how he was called Rainer. Notice the plants with their slightly different shades.

There might be solely these passing phases.

You imagine yourself putting cats on leashes, the squirrels on chains. Prevent these things from getting away from you. Feelings must be fixed, rooted. You try to find feeling in light, to get the lines around time just right.

What blooms in your heart then is not his tree but the palm of his body, how he must have at least wiped against your brow once on some long walk.

You feel his ending up against your flesh.

Remember the hands as you paint.

Remember the way textures recall other names. What begins to beat along inside you, to flow with more feeling, in your blood, now standing off to the side of the sound of

the wet brushes, is a memory of having had once no need for further explanations.

There's no name for this. You were once someone, someone to him. You were once a tall boy he saw as too crowded for his own body.

———

You were not yet eighteen. You'd become this great painter.

You would transform your life, your family tree.

You'd work on one canvas for a year, stand it up against the wall.

Excitement strung you, stopped you, before some more telling plunge into the paint.

You watched yourself.

There was something accomplished if you could just give enough weight to a body. A brush holds you. An inner thigh might be strummed a bit more, as consciousness comes in and out of focus.

You were learning to play yourself, up there in that room.

You were creating your own vision.

The mountains bloomed.

Where was Rilke's real face to be kept. Among your ideas and ideals, up in that room, those mountains, his castle.

He wrote of wandering, among all of these glories, of rambling, of observing streets.

He wrote of being alone, taught you well as a father figure. He'll come to embody many things.

Where would you be left, if you let yourself remain this boy.

Looking in the mirror, you could almost be a man now.

On a canvas, you could turn the body before you into a girl's.

———

". . . all my borders hasten elsewhere,/ rush out and even now are there."

— RILKE

A strength was beginning to fill you, thrill through you.

You were wandering up and down along the water.

Urges sprung up, as they must have around him, and perhaps he'd noticed.

You recite his poems to yourself, one he wrote of piano practice. You paint other instruments. A simple lute in your hands becomes the more opulent guitar.

How casually they walk through the parks, those girls with their fathers.

Carve out space, a secret space, he instructed you.

What could you come to hold behind your name.

They continue to walk by, oblivious, your desire brought more and more into being in them.

He might have seen it in your face, the way you stopped

one day, and turned, to look back. There was someone there behind you. He was leaning against iron wrought into the patterns of flowers, the garden gated.

Growth was held back, cultivated.
There were places darker than those right around the pond.
He recognizes something in you, a bit of himself.
He's picked you to follow with his eyes.

At night, you sleep on the floor, in front of the canvas you're working on. You have barely enough money for an attic room, but you are serious about living only from this vocation. It's only a matter of time before someone comes to your rescue. You are sure of this.
Every night you think about what you are painting, what you might call it, then turn your attention to the window, go down to the street for some air, to clear your head of the figures you are approximating.

———

Anything could be covered with just enough weight, depth. It was raining out there that night. Water on your face felt lighter past the lamps in the park.
On the street, their eyes file past you. You're far from home now.
Proud tall stems, he wrote.
You were getting taller and taller.

Of his young mouth's quivering, Rilke wrote.
Of his mouth, unused, shimmering, he wrote.
Of his body firm.

In the street, if his hand doesn't go there, if his hand never goes there, if you were to change it in the painting, the way it looks in the painting, one would never know.

Girls groped here may be male.

You're not feeling compelled yet by simpler pictures, potential caricatures.

You scrape back and smooth layers, arresting a life earlier.

You begin painting hands as claws, then stop.

You lay your head against the easel.

One more stroke of the brush, then one more look, one more time.

Think of a name.

Observe the bodies on the street, as you try to let life excite. Compare your flowers to his tree.

Torsos glow in the water, wading in along here, there.

Think of him solitary, in his own light, subtle way arranging again what there is to draw from.

Figures through a life.

Leaves and limbs hold their tension, in resting.

To stand before any example of human weakness. To study inflections, how these individuals resonate, one life up against another.

Crane

Men come and go.

Your watch disappears as you hold your hands in your pockets, walking away from the girls, further out towards the edges of the park.

You know you're growing too old for this, pretending to see yourself in the swans, as something lights up, as you hear someone falling into step behind you, the sky divided into streaks of lit and not lit.

———

Change the time, the place, the particulars of your grappling with your sexuality.

Change the names.

Change the history, your vocation, the art in service of self, your past, even.

What else should art serve.

Who else were you holding with you in your mind, behind you there, anytime you set out, begin along the water, from left to right, your feet melting the snow.

You are reflecting on Rimbaud today.

All you had to do was just look hard enough, and then some figure would appear there on the horizon for you.

You'd see someone like yourself.

Just give it the proper timing, and there you'd be.

Slow and steady was a pacing behind you.

All you had to do was look, and you'd find something out beyond yourself.

The myth of you is not a static thing.

Hope, and there you'd be.

You see yourself in movement, living by following his crossing, over to the corner of a warehouse, then behind.

You see yourself in his eyes.

You would not pause to reflect.

You would involve yourself.

It's not the moon that lights up but the gleaming of teeth, the siding of the warehouse silver then under his hands.

The knots in your stomach grip you both.

You are pulling him up out of some thought he's been lost alone in through all this circling. He is there with you now. You are meeting him, giving his wondering this voicing.

You are trying to talk to him, for him.

It's not just sex, is it.

It's having this existence.

You are guiding by one night out of three. He towers over you in all of them.

You were working for your father, in Ohio, Crane.

You could find men around here.

You have a reason to go out walking after work now. You're not just aimless. They show you they know what to do with someone like you.

You bend down towards the pavement, after he's gone, to pick up something, what looks like a rock but becomes more open-ended then in your hands, revealing itself to be a shell.

What do you hear there then besides the echoing of your own blood.

———

It was somewhere back in Washington.

He was your first man, a religious man in his own way.

He was a way one could come to know this language, rough textures, his hands hooked behind you, like angels on your back, fluttering up and ascending up from knees.

You visit a painter.

You go to see him once a week in his studio with the farm outside where he spilt light, capturing it across a canvas stretched, making it sail into that point he captures vanishing.

Now you had somewhere to be.

He's another one who saw how much you needed.

You saw little else but each other, for weekends and moments. There was work on Mondays. He lived a little farther away.

You liked thinking of yourself as this prisoner in one of his paintings.

You yourself began practicing, first with a pencil, then those more tentative, paler blushes. You weren't going to spell anything quite out, you decided.

You would imply.

Your irises enlarged, sharpened, before the page and then looked up and out to him.

You tried to see more there, the very nature of a reality.

You stretched, with words between you occasionally drifting like waves behind larger thoughts.

You were telling another version of the myth of Narcissus, how in one, rather than staying there long enough to transform into some rooted thing, in going after himself further, in trying to actually touch himself, not knowing it was himself he was reaching to meet, in all that fluid blue pigment covering the canvas of the world, how he would drown.

You were noticing the trembling around the corners of everything now, in his presence. You were most certainly noticing his mouth across the room, opening, to say something else to you, louder.

You ask him to repeat himself. You want to be sure.

Break.

Nothing's fixed.

It all hangs on the gears of the most sudden shifting in your perspective over this evening.

You hold all your cards to yourself.

You think of your childhood tower room, sparring with the dust motes, jabbing inside there with his shadows.

You are still living there.

He's put all his apples on the table.

How they move you, move over and under you, spill all over the floor, as the sun completes an arc.

For a moment, you'll stop, and let your eyes try to adjust.

You could hear your own breathing, now, the way you were laboring in this enjoyment, of him, his space, the way you will, until it will become second nature.

The heart was perhaps the hardest thing to let try and enter here, there in his studio.

It was all in the way he hooks his thumbs, the way he picks things up.

It's like all you saw once in the eyes of the boys who circled your house, as a child, your mother holding that door for you, the years flying as the boys continue going by on their bikes, circling your home, their ages turning, your houses changing, the cities chaining into all these possible routes of escape.

You identified with the story of Rimbaud, how he was pulled under, never to be heard from again, once brought back home, under his mother's wing. It was part of his myth, too. You believed your mother would always be waiting back there for you. You believed you must try to escape her, to try to make meaning more dependent upon your own mouth.

They stood on the platforms and sat on trains around you, surrounding you now, older now, evenings now, never quite wrapping your hands for quite long enough in theirs, when once in a while you did somehow manage to brush, touch one.

You took a train not necessarily to arrive but to join and erase dull times.

There was a line you knew that ended in possibility.

There was a train filled with bodies you wouldn't reflect further on for now. You stared out the window. Your face lights up there and then goes dark.

You moved your hand to yourself.

For a moment you thought it was someone else as searching as you, looking at you, for just that long.

A boxer goes down for the count.

You follow their progress on radios, another taking another fall.

You spit to the side on the street, in front of the storefronts, pacing, remembering the way one had to breathe in measures to keep running in place.

There was a beat to this enduring, and here was a way to be with him, in any excuse you could use, discharging yourself, putting yourself in his parenthesis, painting in his studio, talking art.

You take the train out on weekends. You stand up under the awning waiting for him, occasionally working up the nerve to engage some lingering, fellow passenger.

They pour bottles of wine and you forget things like how they look. You forget things like they have nothing to do with your greater desires, how they were just there for that wine. Later, in the event that they don't exactly spring or flinch from your movements over closer to them, your motivations then dawning on them, you'll be able to believe there might be more there.

His lips are pursed, drawn in a silent hymn, and then there is the occasional rushing out of breath.

You'll notice how boxers in a ring have that ability to arouse you.

It happens when you roar and cheer, are jostled along with the crowd.

You turn, look.

There's someone behind you.

Your father watches you watching these boys, takes you out to the boxing ring. A father always knows.

He must know, but he dies never saying a word to you about such delicate issues.

———

You are working for your father, still, thinking to yourself on the feeling of being trapped, still trying to work with the family you've been given.

You return to work.

Always have a place you could walk off to.

Always have at least one person you could write to.

Always have something to drink close by, something to read.

Pick the people you follow carefully, and at every corner, think over the tread.

Find a way to get out of there.

Knowledge could exchange hands like this.

Find a more foreign one instead and travel with him to his bed.

How could one describe him.

You hide the facts of him far away from your friends for as long as possible, deep away inside you, don't even know his name yet.

He comes into where you stood behind a counter selling candy for your father.

He has nothing else to do.

It dangles before you, the bauble of his military bracelet. His arm like that leads you to a nod, lends you a certain resolve.

Why else was he here where you happened to be.

You could go with him.

He'd be shipping out to sea, leaving again soon, but for the present, he had all afternoon.

He eats another chocolate in front of you.

This was how it was more and more when you worked for your father.

In the middle of a small city, one was left with so little of your identity.

What to do with these expanses of hours, but watch them come in and out of the store, get drunker on the sight of them.

What was there for a boy, or a girl for that matter even, in Ohio.

They're playing Christmas hymns at the Macys up the street.

This could not be your life.

The poets are writing ad copy on the subways and up around Madison, out there, the big city.

Imagination jerked you from one to another, one set of eyes to another, one location to another.

You're looking for some overlooked detail to find love in.

Drowning cool pearls in alcohol, you wrote.

Here you were a man in a park, and he another. You were following him around and around the fountains, waiting for him to look up again.

He looks down.

Increasingly, you find yourself pushed up into these darker corners, see yourself like that most nights.

What puddles at your feet.

Not to worry, one day you'll follow them even farther.

It will take you further and further out in your own consciousness, as you try to remember these nights in symbols, find a new name for yourself.

They'll give you trinkets for a job well done.

Once you finally get to the city, finally leave your father's business, those jobs you'd been working just for him, you'd take your mother's maiden name as your first.

Your name will be Hart.

Down on the street, there will be the sound of sirens.

You're still in Ohio, still up in your very first tower, your childhood room.

You believe you must fight your parents determining your course.

Somehow you'll find a way to slip your coded words out

under the door. In letters and fragments of poems, notes to yourself, you were trying to learn to escape the mundane day. You could now call, name, begin to play the feelings between your legs you feel instrumental.

You're learning.

A tower was constructed.

The floor was scattered with your sketches of the way he'd folded his coat, left it there on that chair, the way his arm spared you, the way later you were just sparring, and nothing more, as he pulled you over to him.

After a night like last night, how might you approach touching him again.

How would you touch again.

How would you work yourself up to that point again, like it's crucial, like something done in desperation only.

When would you begin embracing yourself.

His shirt was a white one with open pearl buttons, to connect their partings, bringing the two sides together apart.

Tomorrow morning on the train you'll be yawning.

He had been passing you and passing you and pretending like he didn't see you forever.

He was closing his eyes now, because he was so close, too close to you to even look at you.

You are starting to see through yourself now.

He passes over you, through you, like some missing key.

What exactly was the meaning of opacity, the way you wanted, required, to use it.

You scrutinized the walks through the park a little more closely, afterwards.

As you staggered out, their muscles dragged you back around the block.

It was this thing that made you feel you could feel more, that broke through the surface of a day, allowed you to begin diving a little deeper.

You'd think it was the first time you'd ever really tasted water, ever really drunk this deeply.

You'd try to think that again and again, each time.

They'd slink off, trailing the haze of a mirage after them.

In the mornings, you'd try to recover your steps to yourself through the poem you were working on, trying not to get too lost.

———

Wave upon wave prompted the desire to see more, froze you there. You may be rooted in their intricacies. You may linger over the moment, the movements further, and farther away.

Once stirred, how would you settle.

It was a point you couldn't cross back from, a need that could never be undone once met once. Someone else was there to be found.

There was a way to keep these nights hushed, while articulating them as well.

There was a way to have meaning echo. There had to be.

In the white light of security, a warning alarm flashes, like a tin can tied around your ankle, making you snap, your mind turn around, cornered.

There's a water cooler in every office.
Something holds one back from reaching out farther.
You'd wait in vain.
You wander the streets again, past all those old churches, once out of work.
Touching you, finding you there in your skin, he, anonymously, swims through your memory, like waking farther out into a dream, then bringing you back to the shore of yourself. Someone else is there potentially in you, something more to pull you, to breathe new life into you.

You trained your arms for them.
Every day from now on must be started as a new beginning.
What created these names, myths, was having no plain words for your feelings. You were not yet represented.
Where were those now who knew how to give a whole life every day.
Each day you would go a little farther out.
You would start anew, better, in the morning.
You would stand before the edges of the sink, staring down into the face there. It could be deceptive. You could try to creep up on your own reflections, surprise them into

out and walk around and around the town, your thoughts towering over you.

Perhaps they've been right about you all along, the way your parents want you to stay there, to work like them. They don't understand exactly what you meant by what you call your life.

You wanted to prove yourself, your points.

Her voice tends to follow you, to sweep through the house.

Sometimes you listened, and sometimes you didn't.

You went back and forth between the two of them.

You wanted everyone to know about your childhood, what you were made to endure at their hands.

Sometimes it's like she's right there over your shoulder, as you are composing.

Your childhood is filled with boats, steel swans, their snowy shadows, these things you harbor that get caught up in the heart, before being able to then move out, as you oversee the packing, the shipping, of your father's candy, Crane's.

You could feel the echoing throughout you.

Who really knows why what marked you did.

In the other rooms, you can still hear them, always.

You drank to shut out their voices.

You could hear him screwing his history into hers, the reflections they'd try to make in you.

Soon it would be morning.

He's not your father.

You might get up and he might still have been there.

He was trying to hurry up and put everything back on.

He was getting his coat. He had a boat to catch.

He was getting ready to leave.

He might have asked if he could stay longer, or he might have offered to take you wherever he was going.

He couldn't take you where he was going.

You have work.

He was back there, finding his shoes.

How many more ways could you write about being separated from him, required by some inner decorum to leave at dawn.

In the bathroom, you would shave after him.

In the mirror, you'd remember his names for you last night, how those names reflected other feelings, the echoes of something else.

You would replace them over a number of nights, in a number of lights.

He was boarding a train, off to his trade by now, through that mist at six o'clock in the morning.

———

You have started looking for respite from yourself in them. You are still thinking of your mother, perhaps, how she'll get no grandchildren from you. You'd reflect in the few, mirrored office buildings.

Water falling could be fierce, but gentle, still somehow, all at the same time.

You would chart your time together, see him as this sublime being splitting, spilling, light and shadows.

He was once just another boy, for all your talk, browsing books, candy, boots, something that might provide you a meaning beyond the menial, these jobs you must work, that attempt to build something that might then sustain you.

———

You were going to become a great poet.

You took time off of your job to stare into space.

You were going to find the key to everything.

What might you pick out to serve you.

How could you open yourself out more. How could you construct something greater, join, hinging upon your own history.

You were going to listen to yourself now.

The truth of your life was becoming more buried in all the accumulating images you had received.

A new life could always be started.

You were going to leave here, to go someplace better.

Hotter, colder, you didn't know.

You had friends you could stay with for some time, if you liked, outside the city.

You'd venture farther and farther out, so you didn't have

to work as much, so you could keep this life feeling like living.

You left, finally, without telling them you were going.

You left without telling anyone anything.

You went to New York, where you would attempt to dig yourself in. You'd return to this city a number of times. You slowly brought bit by bit what you thought you might need up into that small dark room, up steps, your records. And then something even more instantly rewarding, these men, reckless, though some nights you'd still sleep out on their starboard sides.

You would find yourself around towards that place where all the streets slope down. You would make your way up and down and over, around, out towards the sea.

Over the course of your life, you'd go to and from New York like this.

You'll promise yourself you'll try to look out after your own self from now on. You promise yourself you'll really try to be better, get better, this time.

You need to write and not work, if you are going to ever get anywhere. Some will give you money, let you take their floors, give you a bed, food, drink, until you get onto your feet, back on track, in your attempts to constantly move out towards the ends of your perceptions. Some will understand.

You will hone in on them.

You will not be taken advantage of, not you.

You are gleeful and grateful and then at times more discouraged.

You scream out cab windows, down from rooftops, from the beds of friends, out of windows. Whenever you get too drunk, you threaten to jump.

You had a certain faith.

Someone would have to give your work the time of day, sooner or later.

———

You had that moment when clear thinking gave way to the punch.

You were surprised how open men could be in the dark here, in the city. So many men came here for exactly these explicit reasons.

You stood over them in the dark.

You were so close to trying, really trying.

A couple of times, you would really try, come really close, with someone else.

What holds you back.

What has you so desperate.

It is the joy of being in a room with the noise of another's breathing.

You have that in each other, the joy of how it feels. You are drawn to even those who are nothing like you. They remind you of what you could have been.

You'd pick one out at the bar. You'd look out across the

space, wait for him to sail up closer to you, confide what you really like in a man.

Going out for some air, you'd claim you were just looking at the sky, looking out at the water, when they followed you down, as you listened for something to come back to you in those nights.

Speed was one thing you focused on, how quickly it could all happen.

Here there's no need to take a hotel room, if you were quick about it.

It depends what you were looking for.

That's one of the things interesting about a city.

You were looking for more of yourself.

You remembered what you were supposed to be doing here.

You were supposed to be establishing yourself as this poet, a voice of some relevancy. How does it happen, exactly. Who sets the limits, says whether or not you were right for the part.

You'd write when you got home from work, write home. Some nights you'd even write your father. He's supposed to mean something to you.

He'd help you, by giving you a little money.

You slept close to the floor in a bad bed, but it's your choice. You could just get a job like everyone else. You are choosing this life. It's your doing.

The afternoons are more of the same.

You are supposed to be writing.

Having felt locked away all morning, you'd wander around at lunch, on your one break.

You were working.

What is your job.

What were you doing here.

How would you make ends meet.

You take one job and then another. You last a couple of weeks at each.

What begins fluttering here in your stomach are all a mother's old worries.

It's someone's job to deliver the letters, deliver another letter. It's someone's job to get up and get the milk. You know none of these people, not really.

You were walking in the early mornings, all over the city.

You worked here, hid your real life mostly from them.

You felt effusive in a way that one house, one mind, one boy, one body, could never solely contain.

Some nights you wanted to start all over.

Your mother wanted you to write to her, write her.

You wrote, thinking of Poe, thinking of Melville, thinking of Rimbaud, thinking of yourself.

———

One of the ones you try with, he liked this story you told him once about a boy who lost the keys to everything.

It's a story, in part, about you.

Once you'd accidentally locked yourself out of where you

were staying, until you could get your own place. You didn't know what you were going to do. All of your stuff was in your bag locked up in a friend's room. You had no money for a locksmith. Your friend wouldn't be back in town for days. There was no one you could call, but you were able to get up on the roof of the building. You knew you'd left the window open, two floors down from the top. You'd still have to drop the length of at least one floor down.

You hung yourself over the edge of the building before you realized how your body was not going to be long enough to reach. You could see now how you would have to land exactly inside that grated area of the iron fire escape, on that small square platform. If you landed wrong, down on a rail, or step, just one inch over this way, too far to one side or another, one of your feet missing the square under you, you could break your leg or worse.

By this time, you'd been hanging there for minutes, before you'd realized the real danger.

How did you work yourself up to this point.

The building was ten stories.

You weren't strong enough to pull yourself back up onto the roof, forget about it, try to find somewhere else to sleep that night, the rest of the week.

How did you work backwards, once you believed in chronology.

The only way you were ever going to be able to get down from up there was to count, drop, to let go.

You manage to land just right, this one time, to crawl in the window.

It's self-explanatory.

During the day, you walked the piers.

You felt their eyes on you.

By now you may be a man already approaching death.

By night, you are surrounded by their bodies like dark horses in the parks.

Mothers sent them off to here.

There were no manners in any real religion.

It was the excuse of ecstasy, the excess necessary.

It was part of what you needed, to be this consumed, to have none left, to feel yourself making these circles around one of them.

Watch them marking themselves. You've met a man, E. Call him whatever you will in letters.

You're pulled back out on the street, back up to the bars, finding their masses out around the corners, the flagging of their suits.

You'd stay rooted there a while.

They have been just as focused, just as longing, as long as you.

The deeper underneath one gets, the farther out one gets, the darker it is bound to get.

For now, you had nowhere else to go.

Where could one possibly progress from here.

———

This was that one part, that one point, you didn't want to leave behind.

As a child, up in your tower room, you were able to imagine more poems, other poems.

One by one, you descended the stairs.

He would be out there somewhere, someone like you, you knew.

You hope.

You think of the pictures of girls, clouds, streets, buildings.

He was not bound to come to you.

You'd have to search for him. You'd have to find him.

Unless you marked these days, these wandering afternoons that more and more seemed to vanish, unless you began to try and settle accounts with yourself, the stringing them into something else, to let it try to pull you up and out at the same time, to suspend you, you'll start feeling trapped here, landlocked, in this place like no other, a place your parents have never known, feelings nobody else may ever see any grounding for.

Your better reasoning begins to witness, seeing yourself so darkly, splitting yourself into halves, half notes, half lyrics, fragments, haven'ts.

Your muses were male.

You were attempting to write in a too hot summer when everyone else was leaving the city.

You happened to want the same thing as he, out this late, just someone.

You drink too much.

What is the song that makes you lose further control of your senses there, that night.

It's a song that's been silent inside you for some, many nights now.

He starts it again, taps against your chest like leaning up against a bar.

You were just stepping out for some air.

Look up there, beyond all those lights of the highest floors. And what might you see from the bridge, when you need somewhere to be.

You find yourself in front of the sea. Boys sing in their own ways there, where there are few recognizable flowers, when you come down to it.

You'll find someone, a boy from Alabama, a boy in the navy now, spending his first Christmas away from home.

On Christmas Eve, on that day alone, you and he cross your bridge, as you begin that attempt to explain how you hope it might bloom in your words into something more epic.

You find yourself in his hands.

There is so much you want to find somewhere to keep, so much you see. There are limits to this one life.

This could be your life.

You couldn't say your experience had not made you a little biased, a little one-sided, a little predisposed.

If only you could wait for him, like he could wait for you, the next one, and the next one.

If only you and he could have waited for each other equally.

He will be pulling out again.

He will be returning from leave.

It was there before him, but some things couldn't be said. Touch-
ing was a way of trying to continue feeling.

Feelings rubbed more clearly, bare, the night forms itself up
around the air clouding over the water.

Night falls and falls, and could always further. One senses this.
This impression in particular registers. What might the night
hinge once upon.

One tries to quiet fear, the possibilities of confounding, to be-
come more compliant. He brings them in, wastes little time, words
to be questioned more later.

These men, one after another, they come in waves, over the
bridge, out towards the park, out from their single rooms, to look
around.

There is hoping to finally catch one someday, in the meshing
of the lines, for each word to eventually like a wave glitter. Each
image glimpsed to be taken down inside, before falling back, then,

having given just enough, to pull one further in, out, towards that next end.

From all the way up there, on a bridge, staring down at all the meandering lines down below, the traffic, and further out, the pulling off of the boats, what comes into a mind, what does he talk about, looking for a way they might all relate. These tracks through a life, the tracking of himself through other men, down there under his feet, before his eyes, this swelling up around him, that empties all.

You'd just been looking all this time for someone to meet you, who would dare to meet you, head on. You'd been searching for someone you could combine with to make something more fixed.

He'd love you.
You'd believe his feelings reflect your feelings. Mostly.
You believe there are things still to be said.
There must be.
Language is only this shadow falling over what has flown.
In his hands, directions are rethought.
Here is how you become another.
With him, you no longer quite recognize yourself.
You're better.

E., he says he sees a mother of sorts in the sea, out under the moon, the lee, all over the world.

He sails.

This could be your one great love, everything you've been trying to put into words all this time. It could be him. How you could love him. How he could complete you. How the sea could contain it all.

———

These initial feelings, eventually, settle.

There's always another E., a J., the sea of them.

They have many names, but they wash away.

You're still going out, from one place to another, all over the world.

It's raining that night, lightning even. The lighter it gets, the less you could see someone like him staggering so obviously, but there are still those certain ones, those certain hours, those few just before dawn, while he's away.

There are those certain places, always a Jason, or a Jeremy.

That's all there would be for you right now.

He is another insisting it take place, where you once swayed with another, his shadows now floating there before you, in the water, out over the water, shaping itself inside your thoughts.

Everything versed a sureness.

You see how you could never completely join, not with this one, not with him. Something is holding you back, that last ounce of yourself you want preserved.

You can't give everything.

You see how you and he begin to separate down into these parts around each other, trying to relate.

To you, every man was beginning to be made up of only all those before. You add them up to each other.

As they threw you around, you were one constant through them.

What could you do but look for others, believe you were not completely so lost out there, find he was not so completely irreplaceable, either. Not even Emil, E. There are others. He is just one sailor out of a dozen more.

Your mouth begins rending, while your body waits.

You watch the ships docking, then departing.

Things would never go back to ground quite as firm for you. After a certain point, it is like you are already gone, though you will try to get back. What happened between you and him, just how serious it all was, will remain open to conjectures for quite some time.

Just in passing, one man mentions Melville to another. You believe you now know what that might mean.

You have started attempting to articulate the sea, further.

———

Reading Whitman in summer leaves of grass, you reflect.

You'd one day direct this course, to those coming up be-hind you.

When in doubt, you turn to the purity of a boy, that full stop of any garden-variety Rimbaud, that could pull you up out of your books, bring you back into life, connect you somehow.

There is life there in front of you.

What had Rimbaud taught you, what lessons.

How he went out on a ship, to leave his poetry behind.

There is a connection that hinges your heart.

You would create meaning, make meaning.

You'd not heard much about his father, just always Rimbaud's overbearing mother, when you were still mostly a boy only following their legends, myths. There must have been a reason you were this way. Those reasons must have had something to do with your parents.

Rimbaud had already lost him, his father, somewhere around the time he was five or six.

His father was a captain, in the army.

You were not the only poet something like this had occurred to, to grow up without a father, but you felt you needed these precedents, these men with their names. You needed this history. Fixing your image in their legends will pull you further from your own life. You try to pull a body to you more like what you believe to be yourself.

When you were still relatively inexperienced, you'd read a book about the ship called the Narcissus.

In letters, later, you'd jokingly call yourself Ulysses, though one or two names might have been more fitting.

You knew what to expect, how the line of the sea would

drift back out. You knew that. You just didn't know how much this would one day take over every direction for you.

You know you are going overboard with this a bit, but their white suits are so conducive to good old metaphors.

Good Old Boys.

You know it is something they mostly wash away come morning. Sailors surface, then ship out. It leaves you with plenty of time to contemplate, to anticipate, a reappearing.

It gave you hope, handfuls.

Glaring bodies on the street stare back at you from all sides as you silently recite to yourself Rimbaud, Rimbaud.

Who would be proud.

This was what you've begun making of your life, what you've begun making to leave behind.

You write about water, that endless mirror.

You count on the men in their suits for sailing.

Pretend you still have the heart for it even on those days when it feels there is no escaping it, your cells.

Think of their prows, their prowls. You were proud of them, as you wrote about them as clouds, as flowers.

Waiting for your ship to come in is more and more waiting for the money to one day be able to leave all of this for a while, the city. You are tired of so much of this place already. You're not even thirty. You want to see Europe. You're walking back and forth over the bridge by yourself now, going through paces.

You could see everything from there, perfectly, from that vantage, you told yourself.

You were thinking, hoping, something might come to you, on the top of the roof of your building, the city spread out below you.

———

You'd go through them. You'd find all you needed to know in and through them, following their directions.

They would teach you.

They would teach you how to lose yourself, how life veers, how chronology, in memories, is mostly left behind.

You want to reach out, to see more. Life should be even more expansive, even more encompassing.

If you were in his position, on his boat, with him, behind his eyes, with his men, what would you learn. What would you have seen. What must you know for certain by now.

You write letters, deep into the night.

Ulysses spent ten years at sea. Then, men lived longer, still saw the need for wives at eighty-two.

Going to leave the past behind him, Rimbaud's father enlisted at the age of eighteen. He would never really return. How old would he have been.

He was once going to write, though in his eloquence for expounding on wars, he'd settle on military correspondences.

Imagine if he was in control of his own myth, how far he

might have taken it, if he didn't need those nights to rest, if he never needed to sleep, never needed to answer his own body.

Imagine if he spoke in even more fluid languages, attempted to set a much different course, with the few facts you've been given to work with and upon.

Imagine if his end is only the beginning.

———

He was never to see his family again. He left behind a grammar book, one thing that is found in the attic or out in a barn.

These lines repeat over time through similar lives.

His father dies, and you are inventing him, that father, as he had once tried to invent himself.

If you were him, you'd sail to Alexandria, go for employment in a marble quarry, become a foreman.

It would become his life through its limitations.

Rimbaud will call the time he spends as a poet simply a vacation, a preparation for the actual living one day in the future his verses foretold.

Those he leaves behind will begin picking up the pieces, once he is gone.

At the helm of a ship, he would conquer. Contemplation from this spot would always be one-sided. Looking at all the pictures of the trips depends on where you now stood, as to how you'd eventually read their meaning into them, how you'd carry those images on through you.

―――

"I am Rimbaud."

— H ART C RANE

Your fear was being linked too much with your mother. Childhood was always moving. Hope was carried on board, carted on ships, like his father's last words, all on board.

Memories are never static for you. You must take action, must do something with it all, all you now knew. You couldn't move. Those shouting matches become your first memories, those poundings. Rimbaud's father throws a silver plate. In his mind it makes a sound like a new music. You wonder if this runs in the family, this streak you find in you, staring off into space before him. Off at school, Rimbaud plagiarizes a Latin translation, and he wins much recognition. For the longest time, his teachers will not suspect the slightest thing.

It is a feeling in his stomach that wakes him in the middle of the night. That's how you two are alike.

He finds a pen, a desk.

He goes out to the barn behind the family's house. A good soldier does not question his commands.

You follow his example, would travel further, farther, wider, would never be settled.

Just give you a place to rest. That's all you ask. Surely somebody would pick you up off the street.

You were drinking deeply from this river of his lore.

You needed a Verlaine.

You were out drinking with those sailors, again. Increasingly, this is how your nights in the city are spent. There is always at least one man willing to have a drink on you, another drink, on the house, so to speak, even if you believe it may eventually entail other arrangements.

It's been so long since your father has sent you any money, seems to have gone for good this time, but there's always at least one of these sailors for you, one on board each endless ship.

Imagine being drawn to that which would destroy you, like flowers are to the banks of the water.

You write your stories about the sea, try to write them so one could endeavor to find, if one is so inclined, elements related to their own selves sunk deep in there.

You drink to sleep, drink for the company. You drink for the reflections, to try and get it all over with, these long days.

You drink to forget the last time you'd drank.

You follow him there.

The street is called Sands.

You will walk behind him, the whole length of a bridging, follow behind his every footstep, determined to follow him anywhere he might lead.

Here is how money disappears more.

You'll do this late at night, making your way back with him to a hotel they call the Sands. You'll pay.

Your father wants you to be able to stand on your own two feet, stand up for yourself, to be a man.

You remember how he used to dance you around the living room on the top of his shoes.

You go holding them in your head, these memories, and all of these men. You are somewhat proud of your conquests, each and every one, wonder who wouldn't be, but your mother still wants you to consider returning home.

You need to be reminded of this, occasionally, how you connect to others.

There is a structure. Every body would become a new room for you, where you'll end up in the space of your own thoughts, how they joined, met, exchanged, and then separated.

There is a step.

How long have you been out to sea in this city.

It is the thrusting of an assertion, a step that keeps stepping behind you and echoing, until you reach the edge of where the sea begins, in one place, not crying now over this small feeling you're feeling, trying not to mind this loss, another body always bigger than you.

Don't come apart. You some nights find the touch of a mother with a man.

You couldn't keep a painter from painting, a dancer from dancing, a man from mating, a sailor from sailing, or this wave from this crashing.

No matter how hard you continue trying, you can't hold it back, trying to get all these sides of your self onto a page, assemble them there.

How will you live, exactly.

Thoughts intrude, huddle inside you.

What do they hear when they hold your body up in their hands, up to their heads. You are trying to tell them something, whispering in their ears. Even if you wrote of it, you could never publish it, not unless you hid somewhat what you might be talking about always.

There is your mother. There is your father.

You were trying to tell, show, what it might feel like to have your story trapped back behind all these symbols, these silent exchanges, their numbers.

Who could open you up. What could be in furled.

In just the right words, feeling is left running.

They come out of their tiny rooms, tiny offices, with all their human holding back, throughout the day.

Where would you find these men every night.

Where would you locate their body then in whites.

Where would you take them in.

They never told you their real names, but you would perhaps recognize them if you ever saw them on these streets again, walking up and down these same docks after dark, pulling out again. By mornings, they have gotten ready to set out on that never-ending line before them, again.

By vocation, these men, these sailors, travelers, wanderers, must never fall into anything too deeply. You are learn-

ing. You have learned. You would not invest any single one with everything.

The anchoring of any roots would be quite antithetical.

During the day, you stay in a hotel room, thinking.

At night, you wonder out and over to the dark of the yards their boats will swing out from eventually.

Some of them will bring you aboard.

Some of them will show you immediately they know just what you want. You drink together. They will ply you with more. Did you want another. They wanted more, even. In those various lapsings of your imagination, feeling the need to describe this somehow later to others, what you might have seen in all of them, in letters, there would always be the falling back on Adonis, Apollo, gods, good sons.

You were a bright one, a thing of healing, looking to a twin, a brother, to hear you speak.

Another hotel is a man's name.

He's warming, pushing you up against the ground there, then pulling you back up, up, up into his hands.

Imagine he loved you, too.

You're in love with some mother's son.

All that night long, it happens in silence across from you, that bridging.

You are walking over it again, together, the bridging of your body and another body.

You search them out with their names across shirts, feel you really know some by these tags, their tugs, keeping tab of these nights, the way in your mind you have touched up

against again, and again.
 They like you a little above them.
 You like them a little below you.
 They watch you slipping off from the bar.

You like them to appear as shallow as possible sometimes.
That's part of it. You know exactly what they wanted. You go
ahead and admit them, as long as they are beautiful.
 You let them into your room.
 They are beautiful to you.
 Some of them let you read to them.
 Some of them saw you as this great poet.

In the dark, you suspend across from each other, bridging
like this, your eyes bringing you closer together, to place
each other better, perhaps even name feelings, something
seeming now to have escaped you.
 Here is how they press up against you, making your body
ripple. You sink yourself as far back as possible, waiting for
their departures you know are coming.

——

When you're thrown out of parties, because of the drinking
you can no longer control, now you know where to go.
 You come back to this spot again and again, back to this
one spot by the water.
 The night air wraps around you, covers you almost com-

pletely, washes over you with each step farther out, your senses quickening once out in it.

You are alive now.

Forget silver and gold.

Find a way to keep the moon up in the sky, over your hands.

He's pacing himself behind you.

You won't know until you turn and face him if he's like you, another someone like you who's been there all along.

Some of them would try to use this knowledge, these nights, these meetings outside, against you, but blackmail will be more and more laughable, the further along you get.

Surely you've been accused of much worse things by now.

Haven't you.

All the sailors are in their white suits.

All the guys are waiting for you. Did you. The drinks are on you.

You'd begun disguising yourself as one of them, even, with no ulterior motives. You were making a spectacle of yourself. People would crowd around to hear how daring you'd been the other night.

You are only calling out now in your own way for some solace.

You had them in your sights.

You add the combinations of them to your thoughts.

How they continued to turn in you like keys.

They return to their ships. It must make about a whole

fleet for you by now. You return to a small room. A cycle had now begun.

You scared some of the older men off.

It was that shark's tooth around your neck, the way by now you know just what you wanted, you claim.

They think love must be the furthest thing from your mind.

It's the way you're not afraid to drag it all out there into the light of the day, not anymore.

Not anymore.

The party was over, anyway. There was nothing for you there, anyway. You were going out, heading for the door, for the shores, even drinking during the day.

A crude homo is what one of your contemporaries would say. Some of them saw you more and more in this light, declining invitations to meet you out somewhere for a drink.

You wanted to talk poetry, but just look at you, they'll say.

Take a real look at yourself.

When was the last time you wrote.

You're no longer writing poems, not really.

You write letters, many that have gone unanswered.

———

It is necessary to let some concrete facts go, to begin to carry on.

Touching them will require a more acceptable incarna-

tion for you. It will make you feel you are beginning to slip away from yourself, unless there is a story to surround it, assuring you.

You have certain things now you felt denied you as a boy back in Ohio.

You slip further and further away.

These men must mean something to you.

Your actual story takes the more human form of a character with already delineated limits.

There were drinks, music.

There was your bed, where you're overcome, by the way he's come over.

For once, just once, this night will be everything, one sure glimpse, pure. You will learn to be able to accommodate, never tire of all the repetitions, these strokings, out, to be able to see land again in the distance soon.

This one night, this one sighting, will be repeated as endlessly as possible.

He muttered something he might or might not have truly meant, how he thinks he knows who you are, thinks you're something else, someone else.

He backs you into a wall, won't let you go.

His shadow blooms around your body.

You follow them, their cues.

You resolve yourself. There is the eventual silence of leaving this spot, alone, echoing the movements of those who had previously gone before you.

You would move on.

You're given his shirt to put back on, a name this night.

You'd stagger.

It comes to you in these flashes.

Be sure that you were no stranger to this. Men took women to bed. Your day will come.

You know that.

What you take is a certain waiting.

Those green bottles hold many things, your hands around their necks. At times, you demanded too much from yourself. You know all you really want right now is to release yourself.

There were thirteen buttons on one pair of his pants. There was a way to hold his leg, position them just so under you, so he would like it, so he would come again.

One or two would one day remember you, keep your picture in those places they see in sleep.

There were letters some sailors couldn't keep, some that would never be able to tell anyone about you, some not exactly impartial to your feelings, outside of their desires.

They'd wash up in the morning and leave. Leave a number of times. Then find their ways back into you, again and again, which starts to feel irreparably past some last remaining boundary.

You are washing up against whatever suited him.

There were the maulings.

You are all liquid, waters.

Here, against this wall, around this corner, he'd stop you.

How desire constantly intruded upon you.

How they break into you, their hands running and braking over your body.

It is all you want, to not want anymore.

How he bends the light, once entering the scene, pulling back the curtains of the city streets.

———

You're waiting for him to appear there, someone who might respond in kind.

You just have to wait there at that one bar long enough, just have to buy them enough drinks.

Sometimes it takes hours, hours off of your life.

How old were you these days.

Sometimes you're still trying to look out for yourself.

He'd come, leave, come. There would be a whole procession of them in white, of hims.

You'd be all liquid in their hands.

It was one way to try and kill the time, without going mad here, being so lonely always, always alone with your words in your head all alone.

You were the first thing some of them came looking for, as soon as they got off their ships.

Don't let your new landlady see them beating the flagstones, the path up to your room.

You call them one-night-sprees, liked to do this now and again, this up and down the docks, from one end to the next, all night.

You are killing time.

They are helping you kill it.

You would like to retire with a whole pack of them to some hotel room.

You would like to be able to call it returning to that original scene, found them down around the ferry, their lights held in their hands.

Which one of you was going to slip up, be seen to be more obviously approaching first.

Which one of you was finally going to be a man, about this.

Huh.

They'll get so desperate they'll tell you exactly what they want, start answering you back, as you question them with your body. You follow them around for blocks and blocks. Then, finally, you'll fall into their final wavings, down behind buildings.

You'll go out and look at the ocean afterwards, think about yourself.

Dear Hart Crane.

There was a feeling here.

You thought about him, thought about him a lot.

———

You'd leave the parties of content friends, back in the city, drunk, leading yourself farther and farther out.

You'd let yourself out.

Like this, every night, you leave New York, are going to the ends of the city.

You'll find a sailor on the docks. It's a sure bet.

There's his stepping.

If you looked now, turned around, he might rearrange his hands for you, be more obvious.

There are these streets you can walk, no matter how drunk you become. You get closer and closer. There are the docks in New Jersey. You can feel it beginning to mount in you, the water all around you.

Some nights it results in your returning to the base of your desk, before those horns of night's ships go completely silent.

You're watching everything else wash away, before you, after you, as you drop these nights down behind you.

You don't talk.

That doesn't mean you don't follow each other.

You learn their language, out here in the dark, learn to like the ones who keep even more to themselves.

You slip through the caging of your body, gauging theirs, their arms long bars periodically around your body, holding you fast.

Their ships parked themselves.

This one was Cuban.

You liked to be close to the water, the harbor, always.

You go down to the street, bring them up to your new room.

You've had to move again. It's money, a number of things.

The sailors pull in, pull your mind off of your own troubles. You kept track of the names of their ships, embedded their names in lines of your work, as you saw them everywhere, chasing them down with your eyes.

When in Rome, buying them drinks.

———

How many other ways were there to fill and disappear a day. How many more ways to live. How many more ways to love.

What were you doing.

Your mother was writing. You're not answering.

A sailor sleeps soundly inside you, his ship having by now set sail.

Here come the Americans, their white uniforms like flags of surrender, slenderly wrapped around them, as they lowered to land.

Havana crawls with bodies.

You are looking for things in the sand.

They have sailors here, too, everywhere. They're a universal species.

Your poetry is one thing, and your life is another.

In the heat of Havana, let him tell you more about where you were, exactly.

You are laying down your arms in the sun.

Sometimes they told you a little more about themselves, like this one has a sister. His sister could help you get letters to him in the future.

You're still only twenty-five or so, but your life will seem to stop here, now. You'd never want to get any older than this, any older than those one or two tattoos, internal, you're bound to have acquired by now.

————

You end up that night in an unidentified hotel room, somewhere in California, the billboards blinking outside, endless advertisements for living.

You were not your father.

In a way, it's just like changing dancing partners. There are those men who flew planes, different stars, cloud houses they fly through.

Nothing more. Nothing less.

You found it only natural to want to cling.

You knew there might not be anything else for you, not here.

You were staying with friends, and they were all around you, throughout the States.

Many of them thought it was remarkable you were still alive, after the way you carried on. You had no home any

longer, not really, but there was free wine, out west, and more freedom.

A different city, another.

Leading men to the front lines, the land mines, and the prows.

On leave, they dance around pool tables, naked soldiers. They are exuberant, reading nothing but through their own appetites.

There was no business like no business.

They come to direct your course.

There was no way you could work and write, and so you moved from place to place, borrowing time. There were those who were still willing to help you.

Your skin reflected his skin across from his skin.

Just for a second you thought it might be love that was motivating you. Then you felt that you knew all along you should have known better. That's what one sees in your face, that averting of your eyes for the time being, until you could think more clearly.

How it might resurface elsewhere, some time again.

Words were something to think over, by yourself, later.

You knew exactly why they were leaving.

They're meant and groomed for this.

You'd have a room you'd escape to in Paris, with a view of their uniforms falling uniformly to the floor, one after the other.

This one was from Spain. You write of him to another friend.

It made a little difference, to share the news.

You knew how much they wanted something, anything, until they were shipped out again.

You knew where to find them, if you looked hard enough.

You'd cross. They'd be waiting for you across the sea, that gleaming body of water.

You'd try your hand in Mexico.

You could write about royalty there, the blood that once flowed and swallowed everything, in the wakes of kings.

You think that might suit you, but you know nothing about their culture, not really.

———

They push you further and further away, more and more often. You can't control yourself. You grab for them, at them.

Think of all those men who hurl their words at you, how some of them stick. Think then of how then none of it mattered in those moments when you were finally met, confronted with what you wanted, equally, by another.

You were working on creating a different world.

You were beginning, to differ.

You were waiting for the visions that would completely arrest you, attest to your vocation. You were a fighter.

The sea was lulling those huge boats out.

You were now counting how long you'd been there, for how many ships.

You had been running from any confrontation with yourself for the longest time.

Once you wrote, the words could become more disappointing, committed, more necessarily reductive of what your hand must have been really searching for, to find.

You were casting about for words, thoughts big enough to live and to expand within. How could you still open them out, extend them more, make them more encompassing.

You wanted more possibilities.

You only had to get somewhere you felt like you could stay, to begin.

You go out, look at your vision, the sea.

It stops you in your tracks.

To see you, it was like watching a brother suffer. Rimbaud dies with one less limb. You'd found yourself up on another one of those rooftops, trying to think your way down, once set, up.

You were becoming number and number to your own life, fragmenting, always at a starting point.

What exactly defines faith.

What if what has stopped you, time and time again, is the loss of whether you were on the right way about your life.

You just want to know.

You just want to see.

You are looking for someone to follow, give up, and you turn

a blind alley.

Another pulls you up alongside yourself, there backing up against you. You attempt the scanning of his face, for a radiance, to direct you, assure you.

You are somewhere in this body, this body like his.

He rubs up against you, your ribcage.

———

It would get darker this time of night, every night, with you in the shadows, your hair less of sun.

———

One woman you think would be perfect for you, the first one that you could see yourself with, loving, that you could settle with, that could save you.

You were getting too old for this life, this struggling alone.

Your plan would be to get married now.

You thought it might quiet much of you.

You met her again in Mexico, had known her a bit before.

This struggling to find some place that would keep you could be realized.

She's convinced you.

You were both just so alone.

She might be just what you need. You'd give it all up, the

nights on the peripheries of various cities that they shipped into and where you followed them. You still write to brag to a few friends.

You'd arrange for flowers for her, arrange for a wedding.

Her house would be covered with flowers, a safe harboring, respectable place for you to finally lay your head, to ease everyone's worrying.

You've finally found a nice girl, like your mother, as she's always wanted. There might be a bit more to you in many people's eyes now. They might start taking your poetry a little more seriously.

There could be more to your story.

It might make your words easier for some to swallow one day.

You could be seen as more important.

———

Look at you

You stare back at yourself in your cabin, on a ship on the way back to America.

There was once a painting of you.

It was a painting where your eyes were closed, where there was no attempt by the artist to account for your soul.

You'll attack that image with a razor, in one of your rages with yourself, before an audience, fueled by drink.

Leave everything to them.

You had your father's razor.

You have a number of things in mind.

You're calmly declaring just how exhausted you are now.
You're 34.

There's a world out there.

One or two sailors' names will come back to surface later,
as your memory is dying.

You would try a number of ways to escape. You've always
tried a number of ways. You could swallow pills again, as you
did as a boy.

On the ship, you'll try to get away, but gravity will pull at
you.

With your hands on the rails, you'll test decision.

———

You're returning to America with a woman to be married.
She's on the ship with you. It is after going to say goodbye
to her in her cabin that you'll finally just do it.

You'll leave the country of Mexico on a ship, to come back
home, before settling down to your work, the new life you'll
have with your new bride.

Aboard the ship, despite your engagement, you have sep-
arate cabins.

She's next door, the woman you'll marry.

They'll give you drugs, to try and calm you down, aboard
the ship, after pulling you away from the rails once.

They can barely control you, but the ship doctors are try-
ing to save you.

They've given you sleeping pills, to try and make sure you'll stay calm aboard the ship, all the rest of the way home.

They could arrest you for the way you've been carrying on with the men.

You've been drowning for quite some time now.

You know that.

———

On the deck, people were leaving you lying there.

There's no way to control you, not really.

That was no place for you, below deck.

You knew that.

You never tell your mother the truth about yourself. Never.

That night, they've locked you on board in your room again.

They've nailed the door, for your own good.

You'd be beaten.

You'd get out, somehow.

You're raving, while this woman you're to marry, who'd like to believe she may change you, knows all about you, waits for you in a separate room.

What if you approached one or more of the wrong men, boys, crew that night. It would make a better story, a better reason, explain how your face got so bruised, so ruined, all

opened up that night.

All your money was gone.

You're afraid now, really, to show yourself back home.

The water this night was black.

You can't see anything in it, not after the way it would swallow you.

They knew you might attempt again, pulled you back down off the rails, your arms a waving cross up against the horizon.

They were supposed to be keeping a watch on you.

You went from one bar to another on the ship that last night, were going to find a way out, to try one man after another.

You've been afraid of nowhere and everywhere, increasingly.

Nobody knows what really happened.

You can't keep calm.

Along with your nose, your lip, your spirit had also been broken.

You jumped in what you sleep in.

For a moment, your arms had this second thought, another hand, and then resigned. You dropped them, like your last poem.

In those waves, there you were now knowing lower.

There you'd end.

Watch you. Watch you. Don't let you go.

Dyer

You were caught up in this continuing.

Your hair is in gobs in his hands.

Good old boys, he whistles their tunes.

Already, it's disturbed, disintegrating, dissolving before his eyes, this study for a portrait of you, this unstable life.

Francis Bacon thinks we almost always live through screens, a screened existence.

This is the problem with a painting. One is always potentially just quoting life.

In the mail, the news will come as no real surprise. One of the men he would liked to have loved has already died. Thinking about death these days, every day, would become this sort of luxury for him.

He didn't mean to hurt you, never meant to hurt you.

It begins with a wind, something he couldn't control. Someone was jealous.

How your blood would stain everything, the covers, color the flowers out there where you are unintentionally struck.

All he is left with, once it is too late, once there is no way for him to laugh it all off this time, your mouth pouring forth, a deep gash, everything inside of you coming out, is the attempt to show this, through those more traditional reflections, your woe, how it distorts, and marks it for you, with all those undertows of some more real personage.

He tells you I, I was how the Greek scream sounded.

You were bodies in a bed.

There had been someone here before you, like this. Before there was you, there was Peter Lacy.

Never forget the way your reflections changed.

You might bend down to drink from that self same spring, that same welling, from the same hand that's feeding you, that may compel you, luring you deeper in.

Here you were, sitting on his couch, his idea, ideal, of a man.

You look right and left because of all of the cars that make noises, outside.

What's there at the end of this, as he comes up to you, down another, darker, alley, down his hallway.

You're not quite there when he's painting you, but your presence will remain always.

In between two places, something hanging.

You're heady with drinking in the night.

Watch you get this, the dazzling of white spots before your very eyes, how you feel.

Up in the room, he concentrates on the line of your legs crossed, paints you, undressing you, crosses your legs for you, crossing legs with you.

In a painting, there's what looked like water spread out and around, under you. This water was black, giving nothing back, a third dimension of any given reflection, that thing that helped throw you back to you, into the very wall of you.

Trying to capture shifting this life, here was what you looked a little like.

In place, where were you now.

Where. Where in history.

Make a leap.

Try to take this unfolding, offering, more firmly into hand.

Give you his body.

No more stable lads.

Compare you to someone else.

Make this tie, seeming knot, another way to try and see yourself even more.

Ask him to take his clothes off, too.

With your limbs twisting for such a short time, like that, this, why concentrate on the facts of dates, those personal mark-

ers, those personal battles, as you are always a little closer to having been gone.

Why ever. There's a better story to be found between you and him. There's the here and the now of how you will one day come, enter his places to make him feel gloriously undone.

You could.

The study of you in this light will be the thing to get at, for him, that he will never quite get, capture, in all its life, the thing that will keep him going, that pursuit of some vitality.

He'll call it grappling.

His body gives purchase against.

His foot slides off of the side of the bed.

How he's going out.

It's to contemplate you, the way you ripple, expose yourself to be so transient, in those shadows, on those occasions, he grasps, the occasional breezes across his chest, as he leaves the window open, hoping.

There were other men who could have easily broken into him.

What you would do, quietly, stealthily, is steal into his paintings, as you pull his eyes down there to that spot that is you.

———

He stood before the coffin of a friend.

They would celebrate quietly, afterwards, all of them.

Now another was gone.

This would shift them all a little closer, him and the group that gathers with him inside of the bars.

Young men filtered through them.

As they began adding up, he counted the bodies he'd known. Another one of his friends had drowned himself in a bath. It depended on how the evidence appeared, though. A sailor boyfriend would jump ship a little later, in his own good time, following this lead.

He's taking it apart in his mind, to enter it, this feeling surrounding him.

Every once in a while an image will come up out of the canvas. That's it, you. He thinks perhaps he's caught something this time.

There's one before you, who was a little like you, would fade a little now in your presence. There would be another one like you, after you, without a doubt, to come along.

You were casing out his room, how much room there was there for you to fit in.

You're not the only one.

You know that from the very beginning.

He may fight being pulled in, sure.

He may try to leave them behind, one body after another, by another, those who've died before you entered.

He may fight being pulled after them.

Where would they lead.

He may try to learn to live within their circling him, re-minding him always of somewhere, something, else.

———

Say it did indeed happen the way he claims.

Say that you do indeed one dark night, while the cats scrape themselves up against the corners of buildings, those edifices, pry your way into his place.

The window gives with a simple pop, a slight, dry, resistance.

You are in now, your shadow spilling out over the floor, looming over him, turning in confusion, attempting to wrap his mind around what now, the sheets thrown every which way, then altogether aside.

You're standing there.

Once he sees your form, your face, over him, though, he doesn't continue trying to cover himself up.

He tells you to come there, closer. You don't have to run.

You don't have to do anything but cross, kneel towards the bed, let him take your head in his hands, rub around your neck.

Take your cloak off, join him, there on the bed. It will be just the two of you, as he tells you take whatever you want, you can have whatever.

He's yours to mine.

Kick your boots off. Take the load of your clothes off.

One day even he won't be around to see what you might inspire, how your presence might make his story better.

You let a match sail to the floor.

His body waits.

You kick aside a can of something liquid, clearing your path to him.

You're not there particularly to challenge his authority.

You're there to give him what he wants.

No more old men for him.

Now he's becoming one. Now roles change.

The carpet in the room is red.

You're the younger one, holding his hands back behind his back, pinning him.

You knew what to do, told him.

In your breathing over him, his composure begins breaking down, with the flashing of your teeth closer.

Laugh, because he'll like that.

You put your free hand deep down in the bed, where, if he were still dressed, his pockets would be.

You could have whatever you wanted.

Here's a man who is not afraid.

He wants someone like you, invites you to stay, and there you would, until you could no longer live with, settle, your own heart.

———

As far back as one could now easily trace you, he will be the

earliest recording of your days, your first documenting.

It's like when you begin to come into being, with him, there already in the middle of life.

What lies ahead will extend from him.

You have some idea of what must have come before.

You could have asked him who this was, one before you, this body you've seen chalked up on a canvas, painted on more, Lacy.

He might say someone who died. That might be that.

He wants to lie here with you, now, George Dyer.

Men can't seem to simply do that, not often enough, not enough these days.

In his hands, oddly, you're beginning to become someone else, more George.

In his hands, oddly, you become somewhat more stable, more like someone for a time, and then at times, you would not quite be sure who you even were anymore, without him.

If they were to ask him how he met you, he might tell them the truth, or he might tell them what he'd bet they'd like to hear.

He's been out to another one of his parties.

That's what men like him did, when they're not prowling around the streets, looking for something to take in. It's how he spends his nights these days, with death he sees around him, haunting everything.

Meaning becomes this tendency to fade.

In the dark, in his mind, he turns over an opulence he could pull, paint out of it.

There's a way you'd be more beautiful for him, a way he'd be more inclined, more likely, to want to see himself, with you. This way you are, when you come to pick him up, where he goes to get drunk.

There's a mirror behind the bar, a drink there you come to see yourself in with him, the glass door, swinging back behind you.

Out at the bars, your palms wrap around glass stems.

He wants to know if you're ready to go home with him yet.

It's not your house.

There's another he's bought, a new house on Narrow Street. He told the presses this is the place where he is sure he'll be murdered one day.

He liked a bit of sensationalism, now and then.

He comes back over to the bar, after a table with friends, pinches you, says he's trying to see if you're still awake. You don't fall asleep at bars.

He's been telling them the story of how you met.

They pretend to be interested.

You listen while he tells you again what he told press.

Two by two, you took the steps up, while the lights on the street were extinguished one at a time.

You were company for him.

Don't forget.

He's trying to teach you what you could do outside of those rooms, where you could be however you wanted with

him, where that's what he wants, how to conduct yourself up alongside him, when the two of you are out in public.

What is acceptable.

It would never quite be you.

He points you out to his friends.

There you were, over by the bar again.

You were more an indication of his standing, when he looked up into your face, from on his knees, before you.

Look at you.

You are sitting here for him now.

How is this chair there for you.

Sitting on the edge of a chair, or sitting on the end of the bed, or lying on your stomach, over him, on top of him, in his mind, nobody would have the right to persecute him for loving you, nobody.

It's not their place.

He was painting you, again, more what your body might do, around him, how your body circled him.

He circles you in the paintings.

He is painting, again, and you see yourself drawn more and more inside.

How could you ever control this. How could you ever measure the extent of your own hand in his production. There are nights when he has such a hard time making the canvas speak. You help. He couldn't do this to you, to anyone, so easily, with no qualms. It always takes something out of him. He makes sure it is painful for him.

It's like painting fate by pointing a finger at your feelings.

He couldn't help it.

He has you seated there, in front of him, a mirror.

There are two views.

He doesn't just paint in shadows, he smears your face, the texture of your flesh, to begin disturbing one.

There, he lets lines run where they must, might, if they are pulled down by gravity, moved by emotions.

Where an arrow punctures, punctuating as if it were actual space, meaning is invited, an affinity to be seen, into his elements of personal import. For him, there's more to you, there.

There's what troubles the most.

———

How memory goes out.

It flickers for a second, a palming that extends, extends, and then finally plants itself somewhere deeply down inside your mind.

He's watching you from across the room, painting you in, from his memories. He'll catch and smear the fluttering of your nerve ends, attempt to pin them down, move them around the canvas like they were furniture you'd knock against, drag from the edges of the room, more towards the center, more safely inside the framing of four walls, the windows blackened in by the nights.

Once back upstairs, you were starting to slip away from him, again.

Look, there you were.

Your mouth is opening, rending, seemingly letting loose more words than one could ever possibly need simple recourse to in sanity.

Steady, with your lips.

You're looking off to the side, your feelings on the table.

Study, you're sitting for him, the brushstrokes this time only in his mind.

He'd catch you later, more fully.

You are afraid some evenings to stare too directly into that light of him, the way his eyes question in the dark, night, there.

Some nights, you can't bear these empty rooms, to see the way he paints them in around you, space around you ceasing to expand pictorially.

Outside is a darkness.

A place inside you opens up, once downstairs.

You pace around and around the town, the city, turning in circles.

He wants to draw this line around you, to keep you living, where, how, and now you began to tend towards absence, already in life.

He'll attempt to place you, to arrange you in the history of a picture, to give you meaning. You can see a strong jaw is nothing but bones, to be held in another's hands. Nothing more, less, scrubbed over, broken up, over time.

He'll later bring you all together, mimic you, any easy banter that may have sprung up between you, and him, lost in those planes of your body, the gestures of paint he moves through wrestling with your image, at times overwhelming him with the mortality of it.

An animal watches over another, just by its being there.

Your face was stretching out under his hands, under his command, the brush's strokes, attempting to tame you.

There was an animal caught in this simple motion, stilled.

You've removed your clothes. He has you doing this for him, your clothes dropped down around, behind the couch, over the backs of chairs. Emotion wraps around you, colors your back, your head, your face, there, as you wait to be able to spring.

He showed you in and onto this.

This was your mattress.

He passed you from one hand out of his to the next.

Your hand was rounded, wrapped around his back, holding onto him.

Those lights in his eyes before you, above you, turning you over him to be below you, lights that move back, behind his eyes, the more settled into the surrender he is provoked. His face before you distracted you from anything flooding in through the windows, any other light, any other sound.

He brought your few possessions over and in slowly.

He bought you new clothes, a nice new raincoat, a nice new umbrella.

Then came the day he gave you a key.

You turned in the door, entered your new life.

———

He took a picture, like getting it in writing, first. He was different. Other painters would have their models sit.

Not him.

He examines you from a number of sides.

He has you down, looking over yourself, in front of a mirror.

He paces back and forth under the single bulb of light in the room, back and forth in front of your face before him, trying to hold himself in, canvassing, wondering where you are, trying hard to not run out, go looking for you, perhaps roaming again. He tries instead to believe he could retain something of you, always, some other way, a portrayal of you, undeniably, he's captured there in immediacies and subtleties.

You're going to tell him where you've been now, tell him, while the one light in the room illuminates you, while shadows from the street make you appear less solid.

You sit there, waiting for him to conclude with you, the yellow light swimming over you, casting you.

He's caught you with red hands, hopeless to deny yourself, useless, believes he knows exactly who and how you are.

The carpet is almost as red as your hands.

One eye now glares from your face, as he turns your head to the side, pushing your face along the stretch of the canvas.

You're there, once again, as you never quite were, in parts.

He goes by and over these last remaining parts like traces.

You were a set of nerves, bundled, contained now by the skin that holds you.

You fall under his hands, with your ass wagging, as you remove yourself further off into the cage of there with him, being drawn into being seen with him.

He comments on the power he sees in your legs, calls it surprising how strong your legs are, inviting to him, pointing yourself out to you, teaching you how to see you further.

The bulb swings back and forth above, over your head and his, throwing these shadows over everything.

It's a perspective, your splitting, another level to you, a dog at times confused before a mirror.

He welcomes this sight of you, a man, an animal, naked.

He puts you down on the kitchen chair, has taken off all your clothes again.

He paints you again, those bones that structure just your jaw, bared more in places, as he spends all this time just going over your jaw, scraping away the paint that accumulates, thickens to the point of obscuring you, going over it again and over it again.

He'd have your strong arms fixed like sculpture, set like stone.

They'll emote, erode, as he makes of you what he will, would, tired, a tongue lolling a bit, a dog tried, the constant threat of biting.

Something is rending the comprehending of your head.

He brings you in to have a look at yourself, to see yourself from two, three, from a number of different angles, ways through him.

Was there anything more immediate than this here.

There had to be.

You're having another cigarette, eating.

Ape-like, one viewer would say.

It's not so much a chair leg as a tail, back, there.

Arms pinned you to a wall.

He made you more and more into an animal, marking you, this dumbed monkey, stopped before his own reflection for some reason.

They'll devour you, sighting you.

This constant fucking is all that seems to go on existing.

———

Already in the gallery, already in the bars, in the sacred halls, their hulls, their galleys, they're singing, again, out on and over, through all their vessels.

You're this new one, his new one, his latest narrow escape.

You're invested.

You've asked him one night how many nails they used for a coffin. You're curious.

He'd have to look that one up.

He'd have to try his hand painting those next, nails. You had no idea how hard it would be to paint a nail. Did you.

Think about it.

Dim wit.

He's buying another round.

You wanted him to use real words, when he talked to you.

He mutters something under his breath, to impress his friends, patrons.

In your head, back home, you are there, still spread all out on that new orange vinyl couch, that gives up suction against the moistness of your skin, releasing it with the sound of a slight ripping.

How your body changes shapes there through his hands.

You are all sprawled out, your legs spread with the further emergence of your desire. You're waiting for him. He's said he'll be home soon. You've left him there at the bar, with his friends, important people.

What time in the morning does he finally get in, that night.

He's coming back in, returning, saying he wants to open a window or something. Says he couldn't even tell you.

You remember what it's like to be on that couch, wake up more, to remember where you were.

Why didn't you come back to the bar, later. Why didn't you come back to get him.

You must have had a reason.

When he comes in, he can't see, can't see straight.

There's a chair on all fours he knocked over.

Where were you.

The cold water in the sink takes forever to heat.

You want to wash your face. You'll talk to him in a minute, might try to explain.

He fears nothing but that one day this will all strike him as an emptied intensity, you there. That will be death.

Say something. Reassure him.

It would lower into another register. The shakiness around things would solidify, once the sun rose, once the room was better lit, connections more obvious now, the place coming together more, no longer as furtive, no longer as potentially fertile as with you still there on the couch in shadows.

Say something.

This was your life.

What if they saw all you did together.

What if someone were to see what you did.

You sat at the bars with your eyes further and further back into his meanings for your face. What does it mean to you.

He tells them all how you've been arrested, how many times, talks to them over at another table.

That's you up there at the bar.

That's what he liked. You were some extreme, some high feeling for him, setting him up for that further revelation, a further descent into his own tendencies, violence.

You know what's to come, as soon as you get home, to-night, to the end of the line, once all the lights on the street end, and those inside are extinguished.

You know what he'll want.

Again, the sheets will spread out around him. You'll give it to him, lying in the bed, with the weighing emptiness, the weight of eternity, that room eternal.

To base a life around this photograph of you there, this painting, this biography, you upon his masculine Gods. You and he were still living, acting like animals, less like plants. You're not for a second stopped in your tracks by him. You were living. Eventually, he'll completely change you. He'll tear up his work, ruin it.

——

Some nights there is nothing that can give him more plea-sure than to back you up into one of those corners, try and see if he can get you to break down, to reveal even more of yourself, unwillingly.

Your manner becomes more and more like stones against each other, like stone up against brick, dragged along and around corners, a rumbling, scraping along inside you, to you.

You are self-conscious about the way you speak, the way you may seem, how you might appear to others.

There's that scrape of his palette, shading a canvas, how he's prepared you.

You had such a hard time opening your mouth some nights.

It felt at times like you were in a little over your head with him.

While he makes part of a life, light out of you, even he then begins making more fun of you.

You don't know what he wants. What. Who knows what he wants.

Did you even know who he was, the artist Giacometti.

You were going to meet him.

Tonight.

He was one of the ones who liked you.

Did you know who he was.

Francis Bacon felt closer to him than any other living artist.

He's not saying he was a homosexual, Giacometti, but he's one of the ones who liked you, who really liked you.

Giacometti seems so relatively at ease around you.

They all notice.

In a bar, Giacometti gets up from the table, follows you down to the lavatory.

You don't know what he wants.

You're barely literate, remember.

But Bacon thinks you should learn some basic French, go off with Giacometti, sit for him. He wants you to come to Paris to see him. Giacometti wants to do your portrait.

They could both do your portrait.

He'd die shortly, so watch this night closely.

Watch it flickering across your eyes, while their heads turn back, hands dissolving in shadows as they're leaving the bars behind them, Bacon and Giacometti.

London. You're in London.

What about Giacometti, touching your knee like that in the taxi, saying he feels homosexual here, like this, in London.

It's the only place.

He painted Genet, you know.

He says you were the one, the only one, the only man Giacometti's ever been attracted to like that before, the only man he'd ever even considered it with.

With you, he could begin to see it. Giacometti says that.

———

One afternoon, while he's off in his studio, you sat with one of his better friends in a bar. There were a couple of things you wanted to tell him, that you would like someone else besides yourself to know. Some of them would prefer you weren't there, though a couple of them like you.

You don't know how much longer you can go on trying to hold all of this, hold everything inside of you.

You felt pulled between so many places.

They think they'd like to be someone like you, that you're lucky, this body in your black suit.

You go out of the house dressed like that.

Some of them think you and he are becoming each other's crutches.

He's a good investment, they'll say. He gives you money. They know. It was hard to watch him living his life sometimes, walking that line of his. He's still living it up.

This was such a concentrated period for him, painting in his grays and blacks, mauves.

He's bought these black suits, brought them home. They arrive there all wrapped up in their bags, cut just for you.

They're for you, all those suits.

He wants to know who else you thought they might possibly be for.

Of course they're for you. Nobody else is your size.

Just don't open your mouth, and they won't think you're such a monkey, always, will they now.

How you stood up straight when he came in.

What were you girls talking about.

Sometimes he would call boys like Jackson Pollock's nephew, who happens to be at some dinner or another, a quiet boy who never says much, a her. All it seems to depend on is whether or not they're young. Seems to be his only criterion for determining conversational gender.

Some of his friends fell for these clowning routines, constantly, cloyingly.

What were you girls talking about, huh.

He doesn't give you money to keep you quiet, now does he.

They all know he's become your life, all know you're his partner or something.

Outside those paintings even, you're his life.

It's more and more apparent every day.

They all watch it happening. They all think it's funny, the way you cling to him, despite yourself, can't seem to see themselves either.

You sat on a couch with Lucian Freud, in another painting.

He never paints you, not him, not Lucian Freud.

Taken together, the way he arranges you, what must Bacon mean for you to mean. Who must you be, have been.

———

The year was 1964, 1971.

It was in a hotel, in Paris.

The line would be displaced.

There was a light going up to his room, and you'd lock the door behind you.

This fine line becomes more and more displaced, as your thoughts roam, reflected reality, more or less.

A little further out, this line of logic becomes more curved.

Let it go.

You give them room, your thoughts.

Closer and closer to your own death.

You drove by the water in the back of someone else's car, not his, listening to that echoing in your ears.

You knew from time to time that you were repeating these motions just for him, for him, these jabs, flexing, then swaying, accordingly, suppressing more immediate reflexes.

You were boxing with your own history, your history with him, trying to not be hit too squarely by what you knew of you and him, just how well you and he embraced each other outside of the ring of the bed, or didn't.

What made for a voice of authority.

It's going on four years.

There would be an exhibit. It would be in New York. He wants you there.

You'd walk around, wondering through the gallery, among the pictures, among you.

All you'll really remember, later, immediately, is the way you'd held onto the black umbrella you happened to be carrying, and the way someone could see something, read something into how you gripped it in your hands, clutching it, a prop, crutch, to hold you more together.

In memory, he smiled from across the room.

The year was 1968.

In 1986, even, you'll still be hanging, on walls, over beds, in sitting rooms, in living rooms. The pictures hang. A picture of you.

When was this one done.

Look at the way your foot angles there, look at that, your foot. They focus on this, one detail or another, during the exhibition. Just that one detail says so much. They'll all say so. He'll agree. In representation, it's almost like a club.

You're staying ten days at some hotel.

He wanted all of his closest friends there for him.

He'd been away, doing things, but he wanted to bring you up, to have you there with him.

Some of them always came along. Someone was taking another picture, for posterity's sake, and his prosperity.

Here's the story.

His friends flash.

Look at all those pictures.

They're giving him another show. There it all comes up again. The thought of your death, looming, will not stop him. He'll carry on. There will be only a little more effort, to hold up his head, than that required before, to look around him, to look all around where you once would have been.

It's all for art, only his art.

Balancing.

Keep that in mind.

How everything would smooth out a bit, once then placed behind glass.

Try to keep that in your head, mind, to not let it get under your skin. There are those shadows there, all around you, those shades of the big brass rings, bed posts, bed. Swinging over him, through him.

It's all his. He's throwing you out from him, projecting. It's his reserved privilege, as creator, to name you or not, make you abject or not.

Here was how to see yourself, through him.

You're coming up to the hotel, your name on a hotel ledger, your room.

What were you to him.

What you recognize in him, in each other, what he recognizes in you, is a common dimension, a suspension, internal motioning towards, anytime you or he rounded each other in silence, stillness, sizing each other, slipping down around you your individual fate, he his fate.

Although it's still a portrait of you, it's also one of him, a portrait of the two of you, melded there together.

He's putting you in a time frame, historical compartments.

This here was your back, and this here was your back, had been, once.

You were trying to hold onto these facts, his facts, fighting more and more.

This was your body as he understood it, and as you will begin recognizing it.

What was your individual damage.

He goes back over it, in paint, painting water now black. Water took over shapes, gusting, and shades.

You'd return in various guises, throughout his life, late into the night.

He's not over you yet.

Guess where you were, now.

He's painting, painting, goes on painting.

No comment on you.

He did not feel like he had completely captured you, yet, exhausted you.

All your perceptions, they'd begun blurring, more and more, over the movements of his time.

You yourself were somewhere outside a painting proper. You were always somewhere back there, in there, around in all those background details, even blacker.

He makes you out, a light change coming down.

You have to learn how to see yourself.

It's almost the last time you'd ever see him.

You're running through the streets of London.

You're coming undressed, undone with him, trying to keep up with him.

To find those very last traces of yourself, what might remain, what would. You must come further undone with him, together with him.

He believes.

He pulls you farther in, over, out, shaping you.

Is this where, how you stop.

———

Some nights, still, you feel new to this, a nude ascending as you become more and more undressed for him, in London.

Up against the wall, there's a scar, a painting being fleshed out, a panting, your mouth opening, how, if only one could fill it, all wet now with breath, movements past your teeth.

He turns you to the wall.

You move your mouth around a spot, your thoughts going out like the lights, all sensation now, sensory. The

room is freezing. Your breath is an opal color, curling. The night spills more over into movements, stringing a trail of thoughts, the circulating of how did you get here, with him, up how many steps.

How many steps did he take up behind you, you leaning back into him, from time to time.

You'd gone out for cigarettes, hours ago. He'd found you in a bar.

How did you end up here, your body weighted up against his, provoking you, turning you for more access from other sides, to claw you, your teeth clipping the air.

Why did he want you, here, to stretch your mouth like this.

These were nights in London, street nights.

He wants you to show him your cards, pinning you.

They'll say you were a bad influence.

They'll say you were influencing him, but he knew what he wanted, had always known. Back before you, he didn't paint for years, with those others before you. There were others, others like you, but not quite as transfixing to him, for whatever reasons, not as long in occupying him, who could open up that self destructive streak he's already inclined to, always had been. No need to blame.

As you were weaving into a bar, through the door, someone's asking him what he thinks of Balthus.

All those meandering lines, Balthus has said of Bacon.

It's like looking down on railway tracks from a bridge.

Outside, there's the cold clouding.

Outside, snow is red under all the lights. American gentlemen are here on business. Someone's buying another painting of you.

There was one time or another. His life was this shuffling back and forth between studio and bar, where somebody's demanding money for you now.

He touches the keys he holds in his pocket.

He pays your rent, gives you a place, too.

————

You barely even recognize yourself anymore.

That's supposed to be you.

He won't restrain himself.

Not hardly.

You enter into one of the bars. You come up close to him.

All they wanted, all of them, was to see what you could possibly mean to him. You could tell that, all his friends.

You're drunk.

They're all looking at you like they're looking for you to pull out a razor at any minute. You've bragged before about how many people you've hurt before.

You could tell them things.

You don't know how to act.

They're watching for it, offering gladly, and grandly, to get you something, to refill your glass.

Did you want something.

The show is you.

They're nailed to the spot.

Another brandy to try and get you more upset.

They want to know if you've ever had to kill someone.

They want to know.

Have you.

They like a good laugh, every now and then, at your expense.

He jokingly calls you a little boy.

You pull his hands behind his back, on the way out, pushing him in front of you out the door.

Who's the little boy now.

What did a man see when staring down into his glass of beer.

What if you'd never really done any of these things you said, never really done anything more serious than picking a few pockets, a few fights.

He was still awake, awake in the other room, pacing the floor, flipping through his magazines, books, looking for one image or two that would speak to him, that he might like to rip out, strong ones to illustrate something for him, something more, else, once in another context, unspeakable.

Who would ever be able to see it all, this you'd begun to piece together as your life, a little more each day.

He's turning over, turning over behind you, knees curling up practically to your chest.

No intention is to be read into the way your arm apes his now raised.

Look at you there together, finally, happily.

One could call you this.

How he opened your shoulder blades out.

How he'd remember you there, once you'd gone, pulling a chair out from the table for you.

———

He's stretching his arms out, towards the painting before him, adding a bird, perhaps a crane, off to one side, watching you be picked over on the canvas.

He's defining the confines of a room.

Your removed clothing provides a contrast.

You could be called one of a kind, a saint, a rare breed.

You'd been seen haunting everywhere, your suit holding you upright.

There's a point at which they would all be invited to patronize.

Your tie was black.

There's a darker shadow falling across your chin, under your heels, down out from around your shoes, that emanates from you.

You were looking over your last nights now, lost.

The year was eternal.

As he begins to attempt to take you in hand, again, you think he's begun inventing you.

There's a mirror or there's a painting.

You never pretend to hope for anything more, or anything less.

There are these blind spots, occasionally, in any life.

You were lonely, those afternoons and early evenings, waiting for him to get done with his work, or with his friends, waiting for the next party he'd take you to, or getting so drunk that he'd have to take you home.

When he entered the room, you stood up.

You'd buy him a drink.

Don't make him laugh.

It's his money.

Here you were, in that same bar again, that same old one.

There was this photographer who likes you, likes to tease you. He's one of the ones always there with Bacon.

Free drinks for everyone.

They were all crowding around you.

They were glad to hear you talking, happy to hear you speak, anytime you were going on about him, him, and even more of him.

They knew what time you'd get there, and they knew what time you were bound to leave, given how much time and money you have left on any given afternoon. You put it all out on the counter.

At all times, like these, there's that money.

You put it all out on the table.

You're buying, compliments of him.

There you go. It's all falling apart, and he knows it. You were having dinner one night, dinner with some of his patrons, and some of those friends of his you felt patronized you. You're trying not to feel too out of place in the black of your suit, in the back of a restaurant. It's on him, all on him.

You're going to buy the drinks, insisted. He's given you money, remember.

But it isn't a dramatic enough scene yet.

Not for him. Not for Bacon.

Remember, you're younger than him.

He calls you her in front of them, to them, commenting on you, speaking past you, with the flick of his still paint flecked wrist. There are still some traces of white pigment locked there, gripping onto the hair on his arm.

He says it dismissively. Don't listen to, don't mind, never mind her, you.

You're wearing a suit that doesn't really belong to you.

Who's holding the purse strings.

Tell them all.

He's let this go on far too long, so long, for long enough.

His friends can't control themselves or hold back their laughter, laughing right along with him, his select friends. On the inside you are imitating one of his own screams, more desperately, still, though he'd never see that right there before him, until it's too late.

Anyhow, it's his money. You know that.

Work is over.

It's nothing serious right now.

He's not working right now.

It's all about him, the dinner conversation, his work.

He'll be glad, thank you, to drink to him.

He laughs.

Had it been four years already. It didn't feel like four years.

My.

It's a sense of something that's now enclosing you, like a gesture in one of his paintings.

———

You were leaving that night and going back to the hotel where he was keeping you put up.

You were going back up to your room.

Outside he could pretend, see there any black thing he likes.

Some nights he can't sleep, takes these sleeping pills. He has to take stronger and stronger doses. You take them out of the medicine cabinet, where he lines the bottles up beside each other and other, little, complimentary things.

There's a wad of money in one of his coats, still up there in the room.

You're in America this time you try this.

You have another drink on him, up there in the room, still.

It's your room, too.

You put all the money you found in his coat, in his clothes, his things, in your pants.

You took all the pills you could find, and drank some more of the scotch.

You were trying to find your way back down, trying to get back out to where he'll still be playing his host games.

You wanted him to really see you for once, just this once, to leave there with you, now.

Right now. Just come with you.

He's shipping you back home.

It's at the door that he finds your body. You are still breathing, deep down inside the black suit slumping up and around you.

All his money is still in the left hand pocket of your pants.

He'll have to call some of his patrons, see what they think he should do now, about you, this in particular, what he should do next. He wants to avoid a scene at all costs.

He'll keep trying for that until it's too late, until your body has bolted, finally, those nights up in the mountains, hotel towers, the frozen light that makes its way down, filling up the space around you, and that slow, sinking feeling of thawing, in the mornings, every morning.

There, that's your face in the mirror.

You were going to jump off the balcony that night, when you came to your senses.

You were going to do it.

As he pulls you down, he wants you to swear to it, swear, to convince him that this isn't who you were, who you might be.

Whoever you were, let you go.

Then he says he couldn't care less.

Not anymore.

What makes a man come to life.

What could he have possibly seen in you.

At first, there must have been something, but you could do him no harm, not now.

There must have been something, something else.

What did he need you for, standing out in front of the lights of the streets, then coming up, in with him.

There's a whole fleet of you out there, but there's only one him.

You were something he thought he could go after.

He sets it in motion.

It's set in motion.

The only harm done, if any, will be physical, he's sure.

He tells you to take off that ridiculous looking suit.

He tells you it should make no difference to you if he's giving you money. You know that. It's just money.

He hadn't thrown you out yet.

There was at least that.

You were coming back home. You might call that this. You might try to, start.

Of course, they'll never say as much to him, but some of his friends, they can't figure what's gotten into him, you.

What's wrong with him.

They wouldn't want to offend him, but they all think it might be you. He has to know. You might be his real problem.

This was one of those necessary little side stories, to better explain the state of him and you, how far along things had gotten. He was taking a gamble here, seeing what might come up, just moving his mouth along, around the table, laughing, and she's one of the ones who takes Bacon seriously enough to try and just get rid of you for him, to actually hire someone to go out and do it, a job.

After all, it's only a matter of money.

She's the woman with the husband who would be arrested for abusing boy scouts.

She's got this thing for Francis Bacon, is sleeping with Lucian Freud at the time. One might find this hard to believe, but she knows someone, who could help Bacon get rid of you, if he's serious about getting you out of the way, really needing to. She knows this doorman, at this nightclub. All it would take is just enough money.

The attempt to carry this out would be the end of her affair with Lucian Freud. It's Lucian Freud who has her call the guy off. He was coming after you.

It's Lucian Freud who saved you.

You never posed for him. Not that you can recall.

Francis Bacon still likes her, though, is still able to laugh it off, to forgive her.

Sometimes in the paintings you were helped under by the water, as the walls begin dissolving down around you, run more fluidly, those barriers between inside, outside, here and there collapsing between life and a further breaking down you believe you might see there in it, underneath it. Believe you might be coming closer to seeing yourself disappear all together.

Up under the water, he's holding your hand, in those shadows, darkening.

You're swimming together in the middle of the night.

No one else would see you so unclothed, as he helps you, holds you, under the water. He's calling to you over your own history, which has slowly become his, like his. You're drowning yourself there with him and in him.

You'd fight, come back together, come apart. Something was missing. Something always was. He says you're hopeless. Helpless.

You're still trying to learn to be a gentleman.

Some nights you were still trying to keep your legs together under the table for him.

His friends won't say anything.

He'll joke about the napkin in your lap, pulling it back.

Ta-da.

Tick-tock. Fort-da.

They're barking with their laughter, like little circus dogs, braying, abrading, abhorring, berating. They're only laughing because he wants them to laugh now. They're learning

to sound more like him, learning to mimic his own distinctive little bark.

These people, they claim, were looking out for him.

Obviously, there's been an intruder.

Did he know what he was doing with you, did he even.

A guy like you can easily become a huge liability. They all know it.

He'd better watch himself.

Look at all that money he throws at you, all the money in your pockets.

There's obviously no love lost between you.

You're going out.

Who knows where you were heading.

You're going somewhere else, better.

Ta, he says.

You're stumbling from here to here, there and there.

He has a little cottage where you'd stay with him until the fights that escalated into your clothes and things being thrown out in the streets, from the windows, front door.

You'll leave them, walk on, all those things.

He gives you a large sum of money to go away with, but doesn't he realize it will be like putting food out even once for a cat.

There was no just once.

There were wants.

They'd never forget.

There were drinks on you in the bar at night.

He'll buy you a little place of your own, but you'll sell it. You could use the money.

You bet.

He's working up in his studio, over in his studio.

Go back over reminiscences of those first meetings.

You were working towards something here, before.

The year was 1964.

These guys would follow you in the streets. You'd buy each other drinks. You know a place to go you blurt.

You fall asleep in the backs of their cars.

They and those nights, whatever night, whatever, all blend together.

You'd just forget that little incident ever happened, how about that. He's working, up there in his studio, his studio towering up over you.

You're sorry, you say, coming up the steps.

You need a place to go, to stay.

Someone wanted to drive you home, and you had nowhere else you could think of to go.

———

You wanted to accuse him of something, anything. That's what you want. You'd think of something. Give you the time.

They'll come and get him where he might as well live, up there in his studio.

He'd pant all the way down the stairs.

They were coming to arrest him now.

There are drug charges, and they'd find a length of lead pipe under some clothes in a drawer.

He'll go quietly.

You're the one who's turned him in. The official word was you worked for him. That's what he told the police, claims to know nothing about the pipe, says you must have mislaid it.

You worked for him.

The drugs, they must belong to someone else. He says as a well-known painter, he has people over all the time in his studio.

What a colorful little life he led.

He tells them how you'd beat against the door, at all hours of the night, tells them you're a drunk, how much he pays you, that he pays you good money.

He needs to keep his story straight.

He says he doesn't hold it against you, that he doesn't hate you. He says he sees how you could do such a thing, be so desperate, even with what he pays you.

He tells them that.

He tells them he couldn't blame you, not really.

He could only hope you'd do the same for him, in his place, decide to speak up in his favor, on his behalf, if you ever have to, some day.

He knows he's not the only one to ever have suffered at the hands of some low life like you.

He'll invite you to take your own life again. Go ahead. It's your choice, up to you. Again, take your things and get out.

Then you'll come back together, once he's had enough time to sit there with his legs crossed, the paper, with his ankles not held tight enough, long enough.

How it's always like this, once you get home.

You and he can't seem to live together.

One keeps trying to pretend not to know where this is going to end up, where this is bound. One always tries. He keeps trying, and you keep trying, in your own way.

———

You and he were going to Athens, on a train, then boat, then even further on.

He is terrified of what could happen once on the water, crossing, on the way over, the whole way.

You and he are staying in another one of those nice hotels, until the scenes begin again.

You are asked very kindly to leave.

This time it's the management.

He must be documented. He's being accompanied by another one of those photographers.

You and he fight constantly now, perpetually, in front of his photographers, friends, admirers, his court, sometimes being so petulant. It gets more and more violent, too, though.

It means less to you, as he paints his own skin the color of bruises, his own face brooding, in the shadows.

He'll be happier with someone after you.

They're all sure of it, all of his friends.

You're sure they tell him he needs to get rid of you.

When you walked into the room, took off your coat, you could hear a mental pin drop.

He's afraid of the way you're circling him, but he won't let it show.

He's with a man from another newspaper.

They're writing about what Francis Bacon does. You start talking.

You won't reveal him, his true colors.

So what you don't use the right words.

He knows what you mean.

He makes the effort to make out the changes in your body language, how the weather in the room shifts around how composed you may or may not be this evening.

You did things for him, too.

———

How about you move somewhere further out, try that.

He thinks maybe he could even paint somewhere further, farther out from the city.

A change of scene could always be good.

It might relieve some of the tension.

At this point, he's in agreement with trying anything.

Whatever, he says.

Anything at this point.

He must have cared about you.

There's a picture of you with one of the ties he buys for you, the way you pull it through your hand, fingers, fist, the fabric knotting.

You could wear your suit to go out with one of his friends, get drunk. He's got some things to do. He needs to get rid of you for a little while.

You looked nice in your suit.

People would say anything, and it would be taken to heart often, depending on whom it was then coming from.

Now the real problem was they suspected you of liking little boys.

Now they'll all be talking about you.

You get the scene.

You'll be staying in Tangiers for some time. He's got work he needed to see to, and you're always drunk, anyway.

What did you expect.

He can't go through with being so separated from you.

As a precaution, he'd register for you two separate rooms in some of these hotels, but then he won't be able to go through with it.

He won't be able to do without you.

He's not becoming a romantic in his old age, is he.

His friends laugh.

Out loud, in front of them all, he wonders again how he'll ever get rid of you, though that's not what he says in the middle of the night.

It's all the days you don't know what to do with.

Some friends were sharing the hotel with you, down the hallway from you.

In the morning, he'd give you and a friend some money for

the day. It's just money. He's having a drink for breakfast. How about you.

———

You tried to open another window, jump from another window.

His friends laugh, when they hear how he told you to go on ahead and jump.

Get it over with.

But a doctor was called for you.

He told the doctor to just go ahead and finish you off, just go on ahead and give her more pills, enough.

In the heat of those moments out of control in his bedroom, those moments that blind one, he still wants you further in him.

He still wants you even more connected to him.

He still wants you, wants you even under his skin.

Look at the paintings as rehearsals for or against these endings.

You were already there, already so close.

There were so many paintings of you.

You had one supporter, one of his friends.

Don't lose you.

You go to her one night when it seems they are all after you again. She's one of the only ones who would never quite be able to forgive him, will go on record even in blaming him for what will eventually become of you.

Francis Bacon says fact leaves its ghost.

Dispute the quote.

What's the difference between being and leaving.

For some reason, he's taking you to Paris, taking you there for the end, that final opening you'll attend.

The year was 1971.

You and he are going along with another one of the photographers. They photograph you and him together. A man like him must travel with photographers these days, days that will be remembered and numbered.

It's here you die.

A decision had been made.

There was one painting of his in particular you are drawn to.

They'd like to know which one.

They'd like to know how your body finally opens out when it does, in a fashion mirroring which painting.

They'll claim to see a resemblance.

Then some would claim it's all over, all after only this one painting. He's only repeating himself, ad infinitum, ad nauseam, and the work had once been so promising.

There was a horizon, in the room between the floor and the bottom of a wall.

Your eyes slide up it.

There's the smallest divide, then resigning, dropping, that most tensile of lines coming to call finally on gravity.

When exactly did you do this.
Your heart is beating, beating.
Too many drugs.

There is more to your body than a number of skin layers.
There's your leg.
There's your lying, there on the floor.
How did it strike one, him, how.
Don't say they didn't see it coming.
It's the last word on a trip.
His big opening tomorrow.

———

You knew what they were going to read into this, what they
were going to try and say now, these words. You knew.
 You leave your print across papers, making the headlines,
your history now sketched out.
 He stretches your importance, and later, he stresses it.
 Fact leaves, a reiterating.

They brought the news to him up those stone steps of the
museum.
 He didn't look surprised.
 Not at all.
 That's what they'd say, all those who were already gath-
ered there.
 Others have him returning to the hotel, where the desk
clerk tells him.

Get your story straight.

He didn't look surprised in the least.

They'd taken you away finally, already. You were all ended and open.

You're better.

You knew the positions expected of you.

It came to you.

They'd say it would kill him, but let them keep saying it. You'd give him and them that.

How must you feel now, feeling nothing. Absence at times is a slow enlarging, too much to continue trying always to walk around.

It's that echoing that won't stop, a feeling like something has been ripped out of him whole. It's the smell of the same old bars, and towels by the basin, on any given morning.

The facts of matter encircle him, keep him balanced on an edge, having another look, one more, before it's too late, anymore, to keep seeing, as he opened his eyes, wider, and wilder.

It was here that you'd die, in his eyes.

Location was only a technicality.

Look over your shoulder.

Watch as he and you tangle in a mirror, your limbs confused with his, and then that commencing to box at each other with tongues, defining.

There's no one, not anymore, no you.

One could see that, across all those imagings of you he'd

later do, as he multiplies you, though they'd called him such a pessimist.

He worries.

He's so scared of the day he himself would leave.

No need to quote philosophy.

Not now.

Riff, think, myth.

It would make him scream, inside, the thought of the last step to take, constantly circling.

———

That year, he might have still cared about you.

Might have.

Again, why did he even want to take you, again.

They are honoring him.

You don't drink the whole time. He won't know where you are.

When exactly he does, he is still unsure, for a moment.

They find your body.

Someone does, in the hotel, bathroom.

How exactly did he care for it, your body.

How exactly did he choose to see you there, in that one and only.

What exactly mattered but this, this accumulation in a final swelling of all movements, your eyelids that no longer would blink.

They wouldn't want you getting in the way, not your body, not exactly.

He'd split you over time, arrested in a progression, out of any ultimate arrangement.

———

Now one day he'd move on from painting you to painting those people who help him through, then, after you.

They will replace you.

He'll try to find what threatens your stability as a figure, while painting.

You manifest yourself in these details, the bolder the better, he has thought.

After you, he's bound to find someone even more willing, naive, blissfully so, someone who will move further and further then into him, with no questions asked.

He won't say a thing.

You know.

You could have seen it.

He'll replace you later on in life with any other, another younger, uneducated one.

Someone else wears a bluer suit and richer shadows, in a painting. How you must have felt your place could always be filled. The two of them wrestle, perhaps more peacefully.

Critics will project.

Anyone could see that's not you, not in those next couple of paintings he'd do. He's more handsome. The lights are

green, yellow, richer. He's started seeing someone else, in the room, in your place. Someone else's clothes are removed, across one panel, background, to the next.

Someone else was high up in his studio.

The ground was littered, laid with you, you, you.

You still were, somehow.

Over time, you'd become an unreliable source.

———

One night, they're already writing his obituary. You'll come up. Of course you will.

Of course you have.

All the hustlers are surrounding him now, late into the nights, and early into mornings, in the bars.

He's on his last legs, doesn't want them to be so smart, never wanted them to be so smart.

What's apparent.

There's nothing else he could have done for someone like you.

What ever was the incentive for the next sentence.

You had your moments.

Who's interested.

You'd always tried to be polite.

You were useful, for a time, in your own way.

He goes on about you, again.

You got as close as one could ever let you get.

For histories now, you'd been quietly slipping away.

He was done with you.

Of course it affected him.

Of course it had.

Living surrounds him now.

Someone in the bar would be cruel enough to come out and say it.

He didn't love you enough.

It was him who had killed you, got rid of you, all of you, one by one, as occasions took precedent, one way or another.

Someone should make sure to protect the next you, the next one, better.

He buries a body in a plot. Would a name, more facts, help understanding more, more clearly.

It's a question of perspectives, as he tries to make his model more into this, his existence more into some fiction, becomes more devoted to how one might be seen. There must be something to connect.

In the dark of the house that now floods around them, their features fold into each other. He brings one home like some flower he's picked, saw this one leaving the park. There's the wet floor near the bath, after the bath.

He is what he held in his hands, under, down, places them down over chest, heart, in lap. There. Better.

A stemming down between, lips still warm, legs squeezed around a having being picked.

One night changes everything, and the world ends for each.

He had been talking at the bar to a guy who reminded him of someone he knew who died, a boy whose picture he had never re-

ally stopped holding in his mind, even when he was starting in on someone else.

Look at these in their frames. At a certain point in that silence, one could no longer tell if distance was increasing or being spanned.

It might be better to move more towards touching, to make a skin ripple. Say something. Anything.

One could seem cold, without enough feeling for others, as he slowly veered over reflections, at night, in the dark of a bed, what one must have been thinking, might have been, how one tried.

One comes to know what they want to see.

A part is gone.

What could be remarked, really, when you could only imagine if it had been you.

The shadows gather form, and weight, as they move out from one, move across a room they painted in, curtains closed to make it a little darker, as he tries to put all that past out of his head, to feel this now here, how it may all be done for now, moving into other hands.

Come back from the window.

One will try to keep these waves inside from taking over, waiting in another room, to become more at peace with the nature of this being here. Moving more towards each other, warming from faces of stone to more true skin tones. One day you might come up with good enough reasons, good enough stories, for feeling this isolated, this remote, remove, life itself.

ABOUT THE AUTHOR

Douglas A. Martin is the author of two novels (*Branwell, Outline of My Lover*), a book of stories (*They Change the Subject*), a collection of poetry (*In the Time of Assignments*) and a coauthor of a book of haiku. He lives in Brooklyn.

ABOUT NIGHTBOAT BOOKS

Nightboat Books, a nonprofit organization, seeks to develop audiences for writers whose work resists convention and transcends boundaries. We publish books rich with poignancy, intelligence, and risk. Please visit our website, www. nightboat.org, to learn more about us and how you can support our future publications.

NIGHTBOAT TITLES

The Lives of a Spirit/Glasstown: Where Something Got Broken by Fanny Howe

The Truant Lover by Juliet Patterson (Winner of the 2004 Nightboat Poetry Prize)

Radical Love: 5 Novels by Fanny Howe

Glean by Joshua Kryah (Winner of the 2005 Nightboat Poetry Prize)

The Sorrow and the Fast of It by Nathalie Stephens

Envelope of Night: Selected and Uncollected Poems, 1966-1990 by Michael Burkard

In the Mode of Disappearance by Jonathan Weinert (Winner of the 2006 Nightboat Poetry Prize)

FORTHCOMING TITLES

Dura by Myung Mi Kim

Absence Where As by Nathalie Stephens

All-Purpose Magical Tent by Lytton Smith (Winner of the 2007 Nightboat Poetry Prize)

Our books are available through Small Press Distribution. (www.spdbooks.org).

The following individuals have supported the publication of this book. We thank them for their generosity and commitment to the mission of Nightboat Books:

> Meena Alexander
> Rosalie Benitez
> Photios Giovanis
> Steven Kruger
> Richard Motika and Jerrie Whitfield
> Helene Winer

In addition, this book has been made possible, in part, by a grant from the New York State Council on the Arts Literature Program.

NYSCA

green press
INITIATIVE

Nightboat Books is committed to preserving ancient forests and natural resources. We elected to print this title on 30% postconsumer recycled paper, processed chlorine-free. As a result, for this printing, we have saved:

4 Trees (40' tall and 6-8" diameter)
1,488 Gallons of Wastewater
3 million BTUs of Total Energy
191 Pounds of Solid Waste
359 Pounds of Greenhouse Gases

Nightboat Books made this paper choice because our printer, Thomson-Shore, Inc., is a member of Green Press Initiative, a nonprofit program dedicated to supporting authors, publishers, and suppliers in their efforts to reduce their use of fiber obtained from endangered forests.

For more information, visit www.greenpressinitiative.org

Environmental impact estimates were made using the Environmental Defense Paper Calculator. For more information visit: www.edf.org/papercalculator